Contents

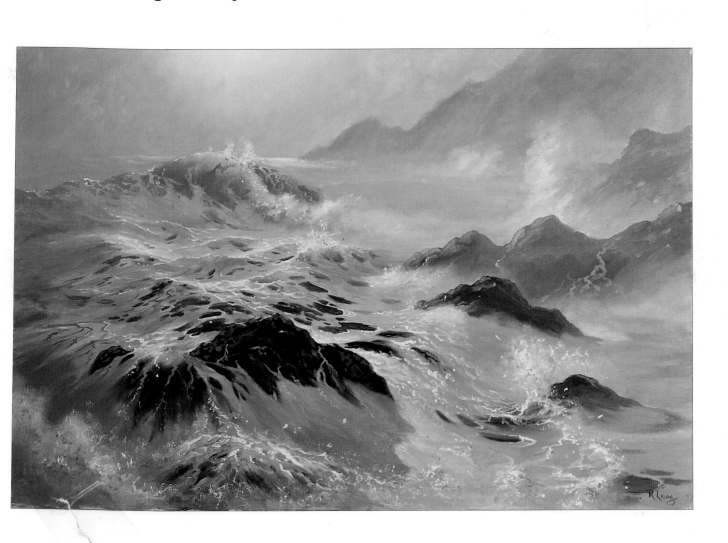

Introduction

These first few words are as daunting as a blank canvas. I am no writer and do not consider myself to be an artist; rather someone who has a passion for the sea and has learnt to portray its moods, colours and movements with paint on canvas.

I opted out of art when I was thirteen (the earliest year I could do so). I started again in my late thirties while out of work, and it was my understanding of the sea which I had observed when angling in my youth that made up for my lack of any formal training in art.

Putting together the many aspects of the sea – light reflections, shadows, movement of the sky and water, foam bursts, spill-offs – became both a fascination and a challenge to produce a painting that captured all the interactions of waves, wind and rocks.

I now travel, giving demonstrations and workshops, during which I endeavour to pass on my techniques and tips to fellow artists. I hope this book will be as useful to you.

Roy Lang

Atlantic Fury
560 x 406mm (22 x 16in)

I wanted to portray the effect that occurs in stormy conditions, where the undertow of previous waves holds the sea back in an unstable wall of water. This was achieved by omitting the background sea and horizon.

The clouds give both direction to the wind and a dark backdrop for the main wave. They also add to the imposing feeling, giving an air of tension.

Roy Lang's
Sea and Sky
in Oils

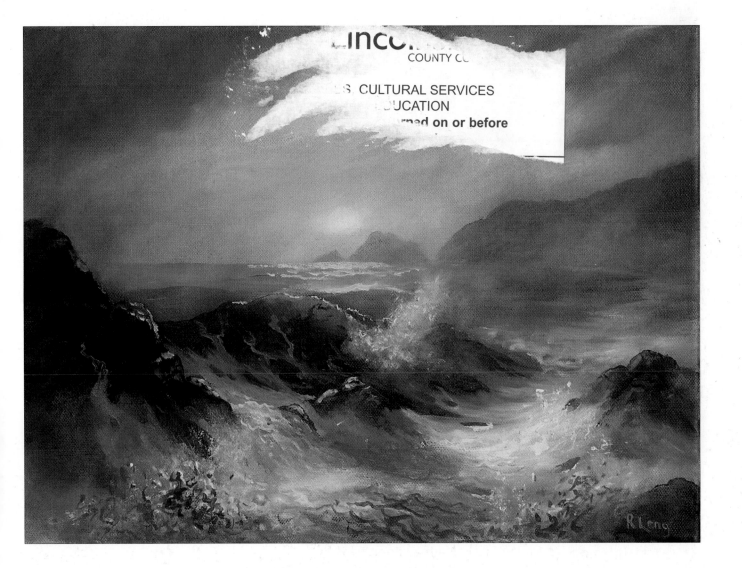

SEARCH PRESS

First published in Great Britain 2007

Search Press Limited
Wellwood, North Farm Road,
Tunbridge Wells, Kent TN2 3DR

Reprinted 2007, 2008, 2009, 2010

Text copyright © Roy Lang 2007

Photographs by Steve Crispe at Search Press Studios, and Roddy Paine Photographic Studios.

Photographs and design copyright © Search Press Ltd. 2007

ISBN: 978-1-84448-020-3

The Publishers and author can accept no responsibility for any consequences arising from the information, advice or instructions given in this publication.

The publishers would like to thank Winsor & Newton for supplying some of the materials used in this book.

Suppliers
If you have difficulty in obtaining any of the materials and equipment mentioned in this book, please visit the Search Press website for details of suppliers: www.searchpress.com

Publishers' note
All the step-by-step photographs in this book feature the author, Roy Lang, demonstrating his painting techniques. No models have been used.

There are references to animal hair brushes in this book. It is the Publisher's custom to recommend synthetic materials as substitutes for animal products wherever possible. There is now a large range of brushes available made from artificial fibres, and they are satisfactory substitutes for those made from natural fibres.

Printed in Malaysia

Acknowledgements
I would like to thank:

The Society for All Artists (SAA) for developing my hobby to the point that it became my career, and for their continued support.

Roz Dace, for her belief in my ability and worth to write this book.

Edd Ralph, for his tenacity in deciphering the manuscript.

Dedicated to the memory of my father, who also loved the sea.

Cover:
Cornish Moonshine on the Rocks
700 x 500mm (27½ x 19¾in)

This is a detail from a night scene; I am in my element when painting these. You can see the complete picture on page 29.

Page 1:
Last Light
405 x 305mm (16 x 12in)

The combination of sunset and sea mist softens the light and general mood of the active sea, adding warmth of colour to an otherwise cold blue. The dark tones of the foreground rocks frame the sunset.

Opposite:
Foam Patterns
914 x 610mm (36 x 24in)

As the title suggests, the patterns were the focal point. The rest of the tones were kept muted, except for the rock in the foreground which contrasts and gives purpose of direction to the water and patterns around it.

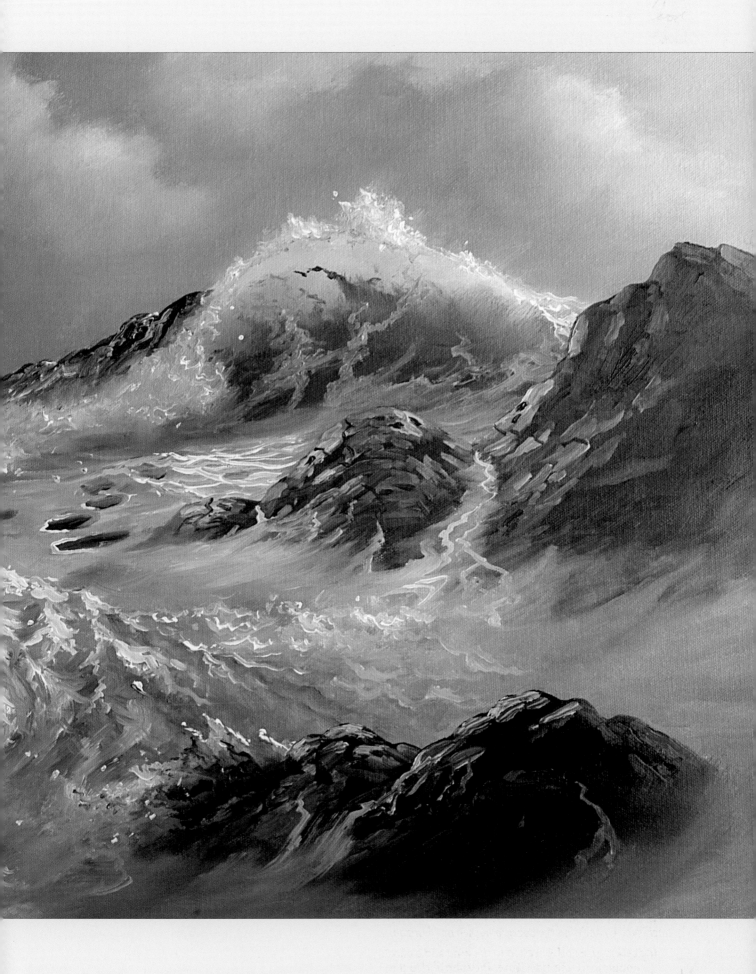

Materials

Try not to be tempted into going straight out and buying the best of everything at the start. Good quality paints and brushes are worth the investment, but other materials and equipment I make or improvise if I can.

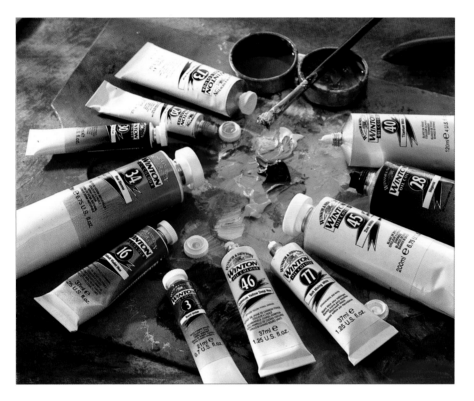

Paints

Oil paints are available in two main types: artists' quality colours and students' quality colours. Artists' quality have a greater concentration of pigment; while students' quality paints substitute cheaper alternative pigments.

Oils became my favourite medium primarily because of the strength of colour and texture, and also the ease with which corrections can be made. They can be worked wet into wet over long periods and blended to soften clouds, mists and foam bursts. What I really love about using oils is that you can achieve a real sense of movement in the water by blending the paints.

Surfaces

While oil paints can be used on a variety of surfaces, I recommend canvas boards or stretched canvases for their texture. I personally prefer to use a stretched canvas because of the 'spring' under the brush and the ability to 'grip' the paint.

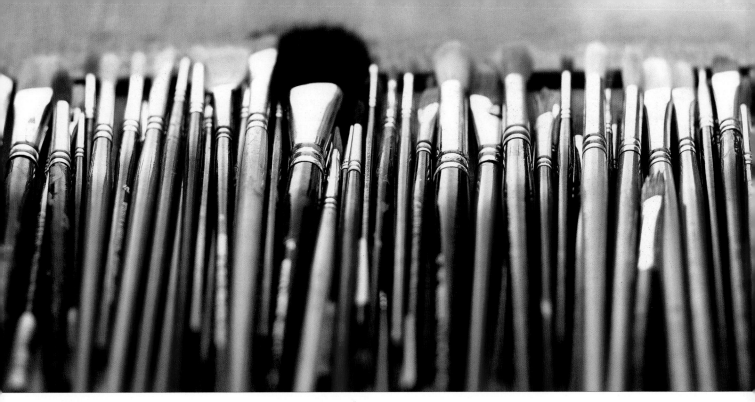

Brushes

There are a wide range of paint brushes to choose from, and over time you will find the selection that work best for you. My choice includes brushes specifically designed for working in oils, watercolour brushes, acrylic brushes and even a decorator's paint brush!

In particular, I use a 22mm (⁷⁄₈ in) series 140 goat hair wash brush. This is designed for use with watercolour paints, but I find it very useful for blending oils.

Palette

I use a home-made palette cut out of hard white plastic. Rather than the traditional shape, it is square with the corners rounded off. This gives me plenty of room to mix and store all my colours. Being white, it makes the mixing of dark colours much quicker and easier (the colour balance shows against the white palette when the paint is spread thinly).

It is also light to hold, easy to clean and it does not draw the oils out of the paint, meaning that they stay 'buttery' and easy to use for longer.

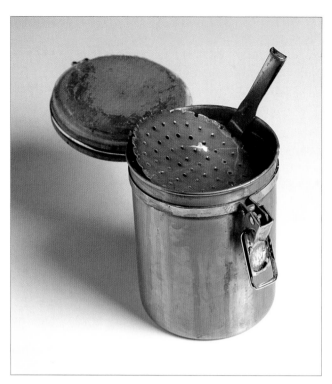

Thinners

Low odour thinners to thin paints for fine detailing and to clean brushes are available, but I find white spirit does the job just as well and more cheaply. It is also much cheaper than turpentine. When using white spirit, I recommend working in an area with good ventilation.

To store the thinner and have it within easy reach, I have a converted stainless steel tea caddy. Inside is a 5cm (2in) length of plastic downpipe, on top of which is a perforated metal disc that sits submerged in the white spirit. When a brush is rinsed out in the white spirit, the solids settle down below the disc, keeping the solvent much cleaner; and likewise your brushes.

> ## Tip
> I do not use fast-drying medium, or indeed any medium other than a little white spirit for some detail work. I find the consistency of the paints suits my style just as they are.

Easels

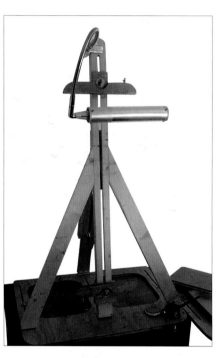

For demonstrations and workshops I use a steel tubular easel for its convenience of transportation and stability. I find aluminium versions too light to be stable for large paintings.

In my studio I have a wooden easel which I built myself. It was designed to save space by bolting on to the top of a sturdy chest of drawers in which I keep my materials.

I also recommend a daylight strip easel light which will allow you to work into the hours of darkness.

My wooden easel is securely bolted to a chest of drawers to keep it stable while I work.

A brush holder helps keeps my brushes tidy. The toothbrush is used for spattering (see page 18).

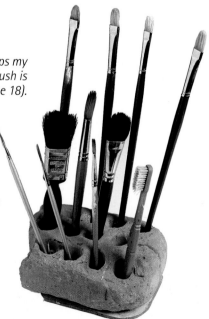

Brush holder

On Coverack Beach in Cornwall I found an old builder's air brick, which was once part of the sea defences. (Though I deny any responsibility for future flood damage!) I bonded this on to a piece of board, and now use it to store my brushes while I am painting. It is great for keeping brushes apart, and this helps to reduce the spread of unwanted paint spots caused by brushes touching one another.

Another method is to fill a suitably wide-based container with dried rice. Any brush placed in to the rice will stay put. This is similar to using the popular oasis, but the rice is more stable and lasts longer.

Other equipment

Other equipment that will be needed includes **cleaning rags**, **cloths** or **tissues**, a pot of **brush cleaner**, a **pencil**, an **eraser**, a **ruler** and a **sketch pad**.

Horizon lines are made easier by placing a strip of **masking tape** below the line prior to painting in the sky. When removed, you have a good level guide.

Another invaluable piece of equipment to me for reference material is a **digital camera**. In general, the higher the number of pixels, the better. I have taken many images with a conventional camera and found the majority to be useless. Having a digital camera allows you to review your shot instantly so that you can retake the picture if necessary. Some digital cameras have a 'movie clip' mode which increases the chance of capturing the effect or moment for which you are looking.

To enable me to add fine detail in large areas of wet paint where I cannot rest my hand on dry canvas, I use a **mahl stick**. I made mine from a 50cm (19¾in) length of 12.5mm (½in) diameter hardwood dowelling, to which I lashed a pad of towelling fabric. You can rest this pad on a patch of dry canvas, while the stick is held in one hand, which allows you to paint using the dowel as a support for your other hand.

I use a medium-sized **palette knife** with a blade of 50–70mm (1¾–2¾in) to mix the paint on the palette, but I do not use it for applying paint to the canvas, preferring to use only my brushes.

A **daylight bulb** is useful because it will allow you to work indoors or at night with good lighting.

This picture shows all of the other equipment I use when painting, including a jar of white spirit and a pot of brush cleaner.

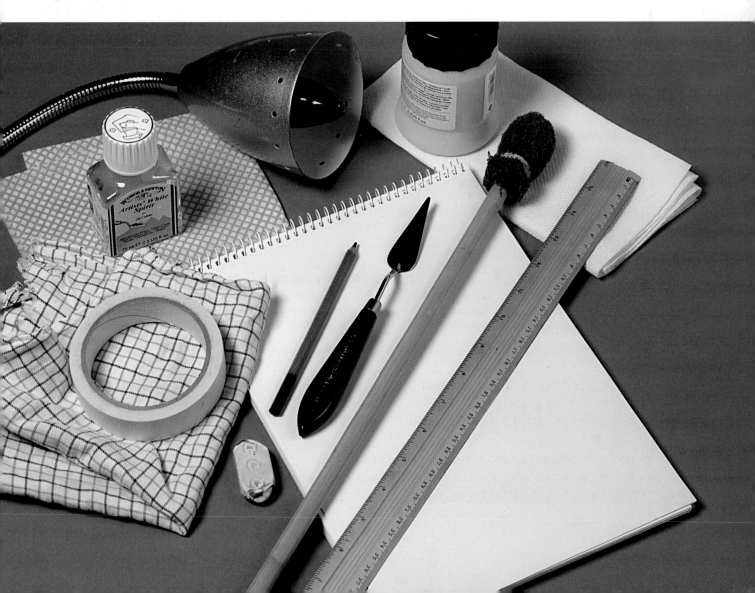

My palette

The nine colours listed below make for a good starter palette.

- **Titanium white** is useful for its creamy texture and workability.

- **French ultramarine** is a very dark translucent blue, suitable for overhead daytime skies and very prominent in night skies and the sea in general.

- **Burnt sienna** used in conjunction with French ultramarine is good for painting night skies, and is also a useful base colour for rocks. See the tip box at the bottom of the page for approximate proportions.

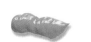

- **Cadmium yellow pale** can be mixed in minute amounts into titanium white, which will give warmth to foam spatters and bursts. It is also useful in skies, particularly in sunsets.

- **Yellow ochre** can be mixed with other colours to produce a good basis for beaches. I use it to depict sun and moonlight on rocks, and to warm up clouds.

- **Alizarin crimson** can be added to most of the blues for sky and foam areas, especially in the foreground. It is also handy to use when painting distant headlands and to vary the colours of sand. Be careful: it should only be used in small amounts in mixes.

- **Cobalt blue** gives a realistic lowering of elevation towards the horizon, and also helps to create interest and a sense of form to foam bursts and patterns.

- **Sap green** gives the top of the wave a translucent look (at the very top edge blend in titanium white with a touch of cadmium yellow pale to heighten the effect). You can also use sap green to paint weeds on rocks.

- **Cerulean blue** gives a good aerated water colour for water spill-offs below rocks. It is also used in the sky at its lowest elevation.

Other colours that you might like to add to your palette are:

- **Prussian blue** and **phthalo turquoise**. Both are useful in foam areas, lightning strikes and for reflective light on rocks, caves and so forth.

Tip

Mix French ultramarine and burnt sienna in approximately the following proportions for rocks: 25–30% French ultramarine to the remainder burnt sienna.
The same colours can be used for night skies, in which case you should use 70–75% French ultramarine to the remainder burnt sienna.

Tip

As a word of warning, I have tried viridian hue, but when put on canvas the feeling in my gut reminded me of the time I spilt a gallon of engine oil on the hall carpet. When painting seas and skies in oils, I would avoid this colour.

Using colour

Colours, in conjunction with their tones, help to create mood and form, and also suggest the time of day and atmospheric conditions. They can also create a sense of distance.

The tones and colours used in the sky will have a great influence on the rest of the painting. It will certainly change the general colour of the sea and light reflected off the waves. It would be as well to remember that the sea does not have to be calm with a gentle sunny sky. A storm hundreds of miles out in the ocean can send in massive swells. Likewise, you can have a dark foreboding sky with a gentle sea.

A good rule when choosing colours is to identify the main colour in the scene, and use a small amount of its opposite on the colour wheel to provide contrast. Pick any of the four colours that are adjacent to these main colours as your third colour.

For example, in the painting below, the main colour is the blue used in the sky and sea. Opposite blue on the colour wheel is orange, so this is included as the second colour. For the third colour I had the choice of yellow or red (either side of orange on the colour wheel) or green and purple (either side of the blue). I chose green to highlight the shallows and the tips of the waves, but hints of other colours are used to liven up the wood of the groyne.

Colours can also give a sense of distance in a painting. Cool colours appear to recede into the distance, whereas warm colours appear nearer. Generally speaking, reds and yellows are warm colours, and blues are cool. Having said that, any particular colour can have warm and cool variants. For example, sap green is a warm green, while viridian hue is a cool green.

The colour wheel
Complementary colours are found directly opposite one another.

The Groynes
406 x 305mm (16 x 12in)

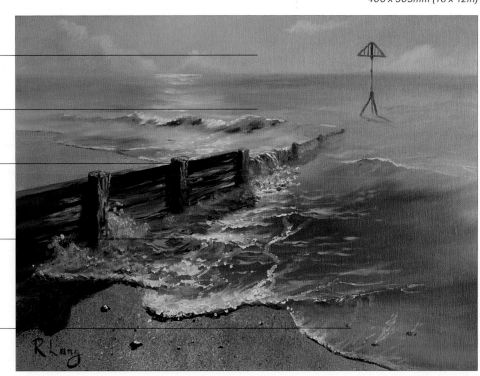

The same colour used in the sky is incorporated into the sea. Note that the sky is simply a lighter tint of the darker sea.

A touch of red added to the sea warms the overall composition.

Orange (opposite blue on the colour wheel) is used to contrast with the blue and draw attention to the top edge of the groyne.

The darkest tones in the sea are contrasted with and emphasise the light tones of the spray.

The yellow of the sand combines with the blue of the sea to give a green colour to the shallows.

Tone

The simplest way to get an understanding of tone is to turn the colour down on a television until you are left with a black and white picture. What you are seeing are the tonal qualities of the picture.

If you now turn the contrast down, the tones will gradually merge into one another until you are left with a vague picture. This demonstrates how important tone is to a picture: a painting with a poor choice of tone makes it harder to make out form and distance, while a painting with a good tonal choice will be vibrant and attractive.

In nature, we cannot turn the colour down with a remote control, but if you look at a view and gradually squint your eyes, much of the colour is filtered out, leaving tonal differences which can then be incorporated into your painting.

Tip

Combining two complementary colours will result in a grey mix. To avoid this, make sure that you only use a touch of the complementary colour.

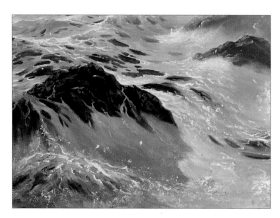

Shadow detail from Foam Patterns *(see page 3)*

TONAL INTERACTION

Tones can be distorted. If you stand in a room looking out of a window into bright sunlight (do not stare directly at the sun), you will notice that the wall near the window will look darker than the same wall a few feet away. This is because the eye is compensating for the bright light and altering the tones near the window.

As an example of how this can be used in a painting to heighten realism, look at the shadow cast by the rock to the left. Notice how the blue of the water is much lighter at the base of the rock than at the edge of the shadow.

GOOD USE OF TONE

Jurassic Walk (painted on the Devon coast) is a good example of how to use tone correctly. I wanted to show a misty atmosphere.

The canvas was divided into three unequal sections, the bottom half using dark tones, and the top left and top right lighter tones. In this way not only was a sense of distance and mystery given, but your eye is also drawn to the pool of water and the red rocks. The contrast between the pale background and the strong foreground draws your eye and makes for a strong composition.

Jurassic Walk
405 x 305mm (16 x 12in)

The rich red of the Devon stone emphasises the complementary green of the seaweed on the rocks. Notice that the reflected light on the seaweed gives it a wet appearance.

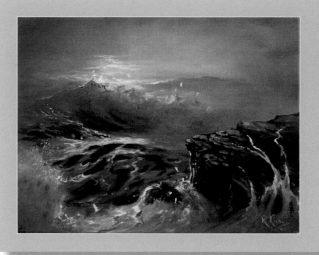

POOR USE OF TONE

In my enthusiasm to make the rock the main feature of this painting, *Reflections*, my attention to tonal balance in the rest of the scene drifted aimlessly, leaving the final picture with very little variation in tone. The final picture is not as engaging as I had hoped it would be.

Aftermath

914 x 610mm (36 x 24in)

Both sea and sky are important when painting the end of a storm, so I placed the horizon a little over halfway up. The dark clouds make an excellent backdrop to the crest of the focal wave, while the solid shape of the cliff captures its defiance against the elements. Note how the contrast between the dark cliff and the light, multi-textured sea is reinforced by the different colours and tones.

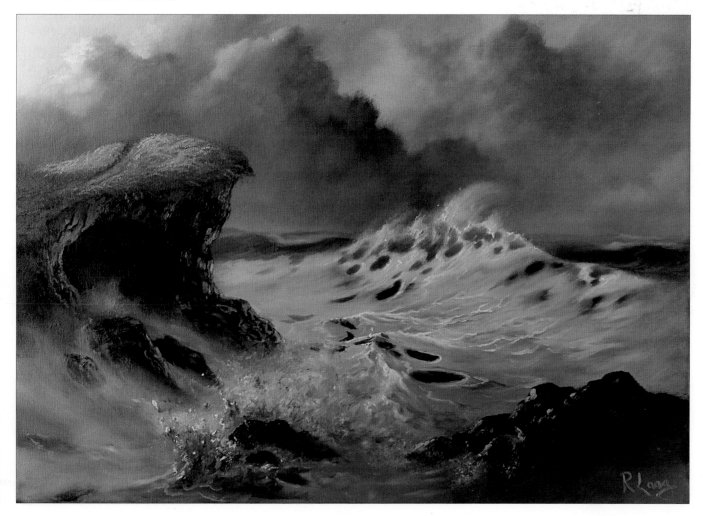

Techniques

Tonal underpainting

Having chosen and sketched my subject, I often use watered-down French ultramarine and burnt sienna acrylic paints to make a tonal underpainting. Squint your eyes when looking at the view, this cuts down on the complication of colour and allows you to concentrate on the tones. Because acrylics dry quickly, I build up tones gradually with several coats. I like to save the lightest and darkest areas for the centre of interest for maximum contrast. Putting dark tones nearest the light makes the light areas appear much lighter than the paint normally looks. To achieve this I find an excuse to put a dark rock or shadow against an area of glare. Moonlit seascapes heighten this effect.

Once the acrylic has dried I can start to lay on colour in oils. I apply paint using one of two methods. The first involves working methodically from the top of a painting, beginning with the sky, moving on to the background sea, then the waves in the foreground, water and finally the rocks; finishing each section in detail before moving on to another. The advantage this method has is that you can steady the heel of your hand on dry canvas. This makes it easier to be more precise and helps to ensure that you can keep your colours separate, so that the different areas do not mix and get 'muddy'.

The second method involves putting a particular colour on to my brush and scrubbing it on all the areas that require it; then building on the scene when the canvas is covered, working from the basic shapes to fine details and textures.

Brush-rolling

When painting wet into wet without thinning the paints, I use a brush-rolling technique that helps the paint to adhere to previous layers. It also gives one defined edge while the other is faded away.

You may find that the technique is awkward at first, but it is well worth mastering and comes naturally after a while.

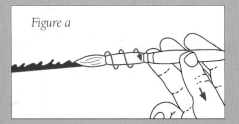

Figure a

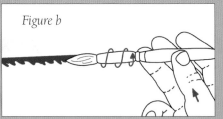

Figure b

Figure *a* shows the brush being rolled downwards. This is very useful for highlighting background waves because it leaves a sharp light-toned edge above the wave and gradates the tone up into the wave beyond, giving the sense of curvature to the water's surface in the troughs.

Figure *b* shows the brush being rolled upwards, leaving a flat bottom to the brushstroke. This is ideal for adding highlights to the horizon, and it is also useful when painting the base colour of a rock or wave to obtain a distinct upper edge.

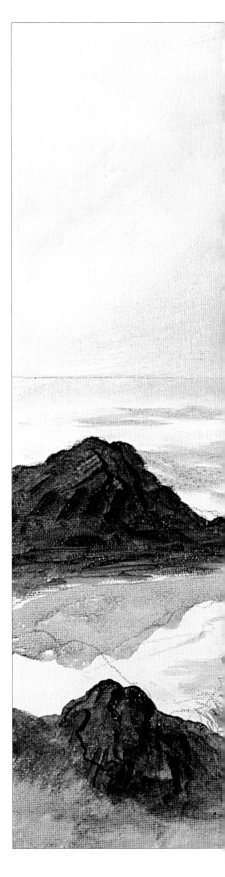

The tonal underpainting for Passing Squall *(see pages 48–63 for the step-by-step project).*

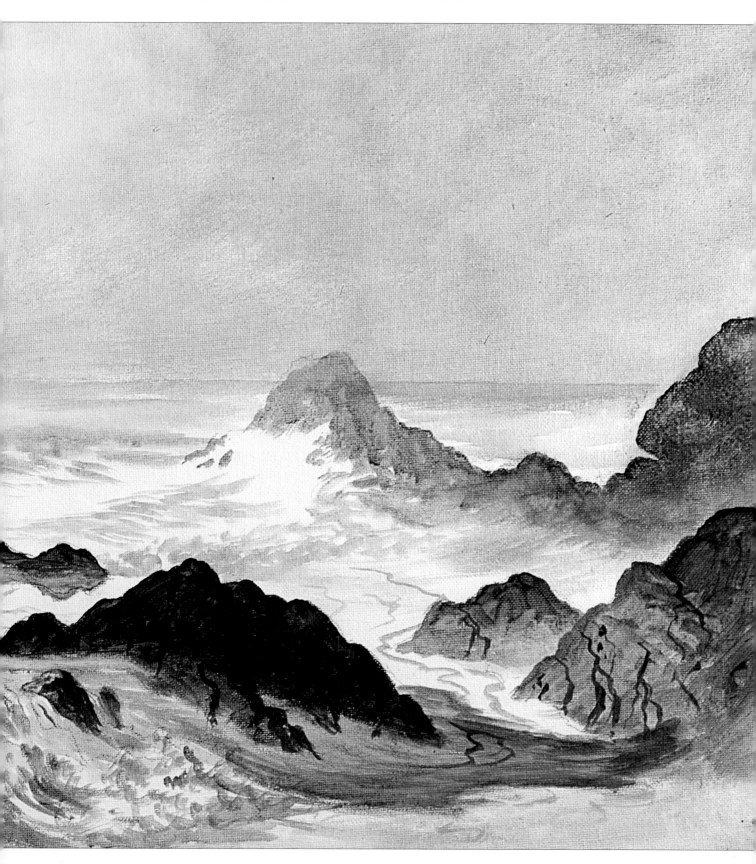

Rocks

Rocks not only add solid structure in a seascape, but also give the opportunity to include foam bursts, rock pools and spills. They also give reason to change the direction of water flow and to introduce complementary colours.

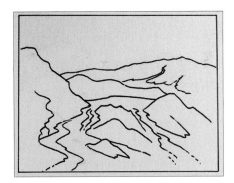

1. Sketch out the composition, using different sizes, shapes and heights of rocks. This will help to create interest in the finished painting. I have used a thick black pen to emphasise the shapes, but you should use a pencil to keep the paints clean.

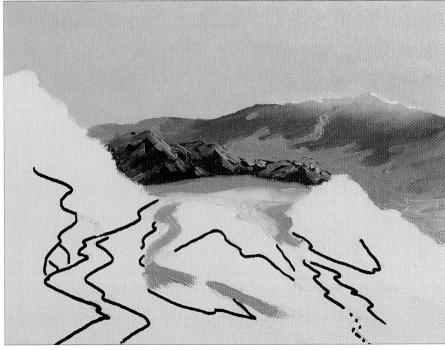

Tip

Avoid symmetrically-placed rocks, i.e. do not place rocks in both bottom corners of a composition.

2. Using a size 6 filbert, paint in the sky with a mix of cobalt blue, French ultramarine and titanium white, with a touch of alizarin crimson to make a lavender colour. Paint in the wave with a mix of French ultramarine and sap green, then add the crest by blending cadmium yellow into titanium white. Block in the rocks using French ultramarine and burnt sienna. Hold the brush nearly flat against the canvas and add highlights on the rocks using the sky mix. Use the same technique with a yellow ochre and titanium white mix for the direct sunlight on the rocks. Finally, paint the shadow in front of the rocks using a stronger sky mix with more alizarin crimson, French ultramarine and cobalt blue. Use this colour for the foam patterns on the front of the wave.

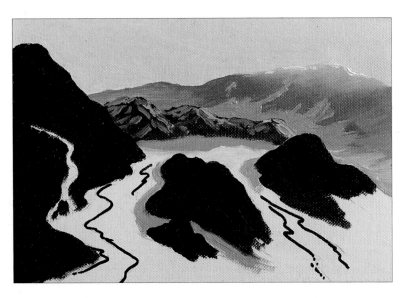

3. Using a mix of French ultramarine and burnt sienna, paint in the rocks in the foreground. Do not lay the paint on too thickly: there should be just enough to cover the canvas. Make sure the upper edges of the rocks are well-defined and sharp at this point. The lower edges are not so important.

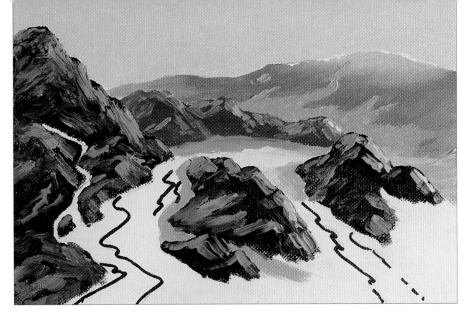

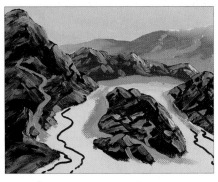

4. Using the same mix as on the background rocks, paint reflected light on to the shaded sides of the rocks, then use yellow ochre blended in to white for the highlights. Add sap green to this mix for rocks on the left, which are further from the source of light.

5. Run in the rivulets with the mix used for the foam patterns, and then add texture to the rocks by using the basic rock mix (French ultramarine and burnt sienna) with a size 00 sable to paint cracks and pockmarks.

6. Make a cerulean blue and titanium white mix and paint in the aerated water cascading away from the front of the rocks with the size 6 filbert. Use a scrubbing motion to ensure that the paint completely covers the canvas, getting right into the weave. Use the lavender mix for the main areas of water, and then blend cadmium yellow into titanium white for the highlights, using the size 00 sable. Draw the clean, dry, goat hair wash brush gently across the sea to create texture and movement. Use a large household brush to stipple spray in the front with the lavender mix, then stipple cadmium yellow pale into titanium white to finish.

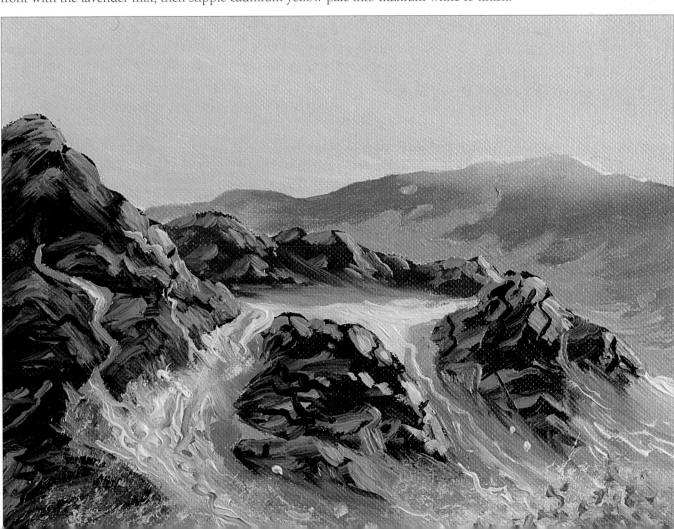

Aspects of beaches

There are a number of techniques that come in handy when painting beaches. This section explains a number of them with an example painting. Unlike all my other works, where I work from top to bottom and background to foreground, I tend to paint textured beaches first. Notice the mooring post on the right. This offers the opportunity for shadows and reflections, which will create interest.

1. Make a rough outline sketch. I have used a thick black pen for clarity, but you should just use a pencil.

Tip

Spattering is fairly uncontrollable, but it is a useful technique. Apply thinned paint to an old toothbrush, then hold the toothbrush in front of the canvas and draw a palette knife across the bristles to flick the paint on to the painting, creating a spattered effect.

2. Use masking tape to mask the whole picture except for the dry sand area. Make a dry beach mix of titanium white, yellow ochre and a small amount of cobalt blue and use a size 6 filbert to block in the beach. Add French ultramarine and burnt sienna to darken this mix, and paint the shadow of the rock and mooring post with a size 2 round. Thin this mix with white spirit to a milky consistency, and create a thin mix of yellow ochre and titanium white. Spatter these on to the beach area with an old toothbrush. Remove the masking tape and scrub in a mix of French ultramarine and cobalt blue with a touch of burnt sienna and titanium white for the sea with a size 6 filbert brush. Blend sap green into this blue as you near the shore.

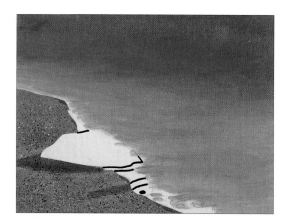

3. Add titanium white and yellow ochre to the green sea mix, and paint in the shadow of the scud line (where the surf meets the shore) and at the base of the rock. Use the dry beach mix to suggest dry areas of sand below the scud line.

Tip

Lay the masking tape over the sketch, section by section. Trace the lines of the outline sketch through the tape, then remove it and cut along the line with a pair of scissors. Replace the masking tape on the sketch. Masking fluid cannot be used as the oils in the paints will break down the rubber.

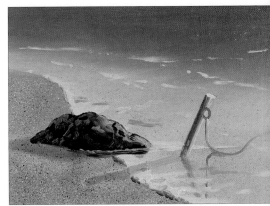

4. Spatter a little of the darker mix into the shallow sands. Paint foam on to the scud line and surface of the sea, using the size 2 round with a mix of titanium white, cobalt blue and French ultramarine. Add more of the blues to this mix for the shadow of the mooring post, then paint the rock following the instructions on pages 16–17. The post is painted with a mix of French ultramarine, alizarin crimson and burnt sienna, with more ultramarine for the shaded side. Yellow ochre is added to the same mix for the highlights, rope and reflections.

5. Still using the size 2 round, paint the shadows cast on the scud line and at the base of the rock with a darker mix of French ultramarine, cobalt blue and alizarin crimson. Use the dry beach mix to paint patches below the scud line where the water has receded, leaving dry 'islands' of sand.

6. Use a mix of cadmium yellow pale and titanium white for highlights on the foam patterns and rocks, and use the same mix to highlight the post and the rope. Add small pebbles on the beach to add interest, following the instructions for painting rocks on pages 16–17.

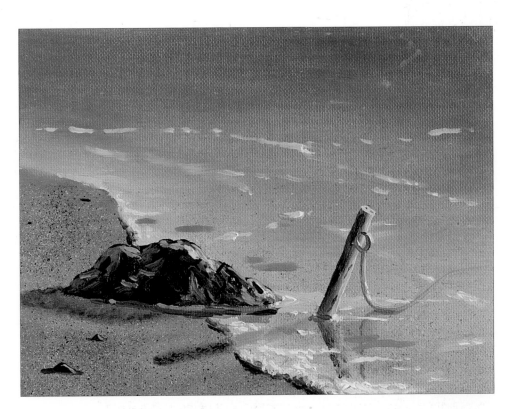

Composition

When I first started painting the sea I ran around the Cornish coast like a headless chicken, taking photographs that I felt sure would give me endless views from which to paint. I soon found out that while it gave me handy reference material for different aspects of the sea, the photographs were of little use for composition for several reasons.

First and foremost I found that it was dangerous to get a shot from the elevation from which I like to paint, and I certainly could not paint *in situ*. In addition, photographs tend to foreshorten the scene and fail to capture the movement and story of the moment.

It is much better to sketch a scene from a safe distance and make notes of the colours to be used. Most of my compositions are based on these sketches, or on a combination of imagination and experience. This gives the artist freedom to strategically place rocks, waves, clouds, foam patterns, light and so forth to lead the eye around the painting.

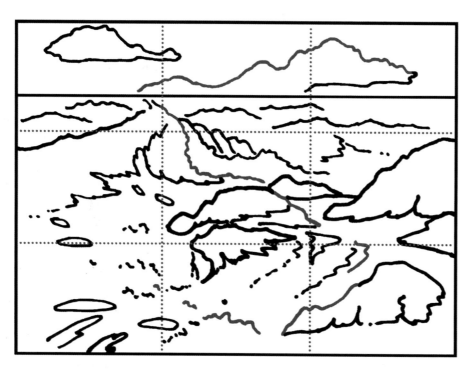

This sketch shows how a grid and the 'S' can help you to plan your painting and guide your composition.

Focal points

Focal points, also called 'points of interest', are parts of the painting that attract the eye. Divide the canvas in three, both horizontally and vertically, with faint pencil marks to make a grid. This is shown on the diagram on the left in dotted lines. It is at any one of the four intersections that the main point of interest should be placed for optimum effect. A secondary point of interest looks good at the intersection diagonally opposite.

The 'S'

Very often I try to get a subtle 'S' or 'Z' shape into the composition. This leads the eye around the painting. In the sketch above, the 'S' is marked in red. Starting on the top edge of the cloud in the right-hand corner, it moves down over the main focus of the painting: the breaking wave. From here, it travels down the foam line to the rocks and into the pool of water: the secondary focal point. After continuing down the cascade of water the 'S' starts to peter out into the boiling area of foam, but it very gently leads the eye back up towards the face of the wave again. This is helped by the elliptical holes in the foam pattern.

The horizon

An important consideration is where to position the horizon line. If you want to concentrate on details of the sea, keep it nearer the top of the painting (as in *Ocean Spray* below).

If you want to feature the sky or give an airy effect, keep the horizon line low. Try to avoid having the horizon on the midline of the painting because this tends to cut the view in half and make for a flat, dull painting.

To achieve the feeling that the viewer is about to be swept into the sea, only show a little or none of the background sea (as in *North Cliff Breakers* on pages 34–35). Obscuring the horizon with waves is another way of achieving this effect. A good example of this technique is shown in *Aftermath* on page 13.

Ocean Spray
559 x 406mm (22 x 16in)

Strong shadows on the face of the main wave give a good contrast to the light coming through the water. The shadows cast by the rocks also heighten the lightness of the foam on the water and give direction to the spill-offs. By keeping the atmospheric conditions clear I could maintain dark tones on the sea. This contrasts well with the mid-tone of the sky, leaving the foreground with its variations of blues and the orange highlights on the rocks to give a strong three-dimensional feel.

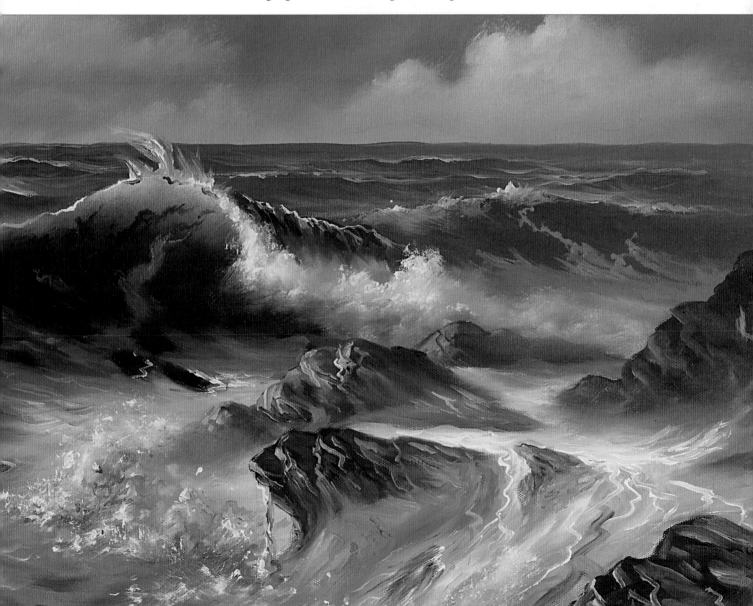

Understanding the sea

To me, the more action, the more interest. Without it, the scene is flat. Calm seas have little wave action so therefore lack spray and spill-offs, resulting in few, if any, foam patterns, wet rocks or beach reflections. A few pointers for common elements in painting seas are listed on pages 22–25.

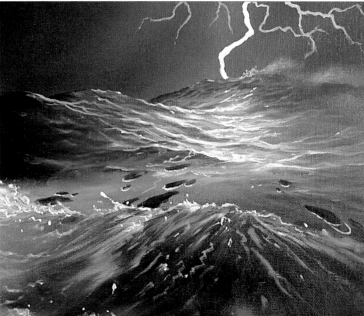

Swells

These are deep ocean waves caused by far-off storms. They do not have a sharp form, and are good to use to break up a flat horizon, giving a useful dark backdrop for a wave painted with light showing through it. In the example shown on the left, I have used swells to reflect the lightning strike.

Swell detail from Electric Blue.

Foam burst detail from Electric Blue.

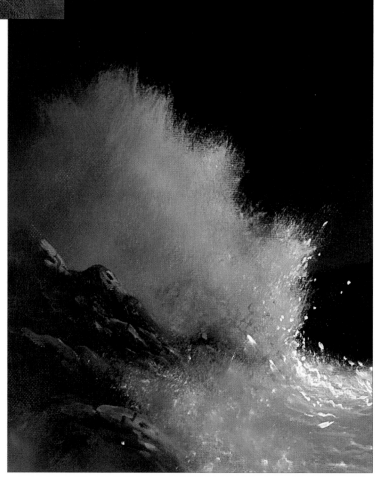

Foam bursts

One of the major mistakes that can occur in a painting of a seascape is in the relationship between waves and rocks and the resulting foam bursts. For example, a knee-high wave is highly unlikely to produce a foam burst the size of a house and vice versa. The size of the foam burst may also vary depending on the shape, angle and size of rock a given wave hits: the burst is greatest against a large, upright rock that is square on to the wave.

You can paint foam bursts with hard or soft edges, but in general, try to keep them softer than the foam at the base of a collapsing wave. You can soften the burst with a goat hair wash brush. Not only does this increase the misting effect, it also gives a sense of movement. Before painting in too much detail, paint in the rock with your chosen base colour, letting the paint run out on the brush near the water's impact point. This gives the appearance of the rock misting into the foam burst.

Detailing of the burst can now be added. Show a little light coming through its base using the same colours as those in the lighter water area in the wave. Water splashes can be added in front of the rock.

Waves and spray

As a swell reaches shallower water it will start to build in height and change its profile until it is recognisable as a classic wave shape. Waves can also form in deeper waters if the weather is sufficiently severe. They break and collapse near the shore due to the shallows and the undertow water from previous waves.

Tip

Look upon the waves as the cast in a play and the shoreline as the stage. The story is told by the interaction between them.

Wave detail from Atlantic Fury.

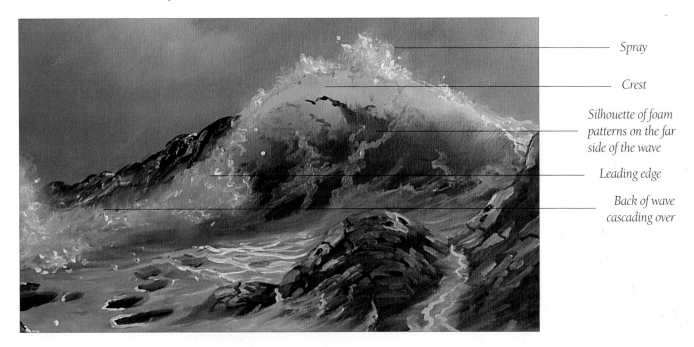

Spray

Crest

Silhouette of foam patterns on the far side of the wave

Leading edge

Back of wave cascading over

A wave appears very dark at its base, and becomes progressively thinner towards the crest. This means that it gets lighter in tone and changes colour towards the crest. In the example shown, I first painted the base of the wave with a dark mixture of French ultramarine, burnt sienna and a little sap green. Above that I painted a strip of cobalt blue into titanium white, at the top of the wave I painted cerulean blue into titanium white.

I then blended these together for a smooth gradient from dark to light using the goat hair wash brush. Holding it square on to the surface of the canvas, and with a very light touch, I worked small circles from side to side, gradually working up to the top of the wave. To add to the effect I then used a sable 00 watercolour brush to paint in the suggestion of foam patterns on the other side of the wave, with the dark colour used at the base of the wave. I also used the goat hair wash brush to paint in the area where the back of the wave is cascading forward in the direction of the shore.

Where the wave is at a crest, the water tends to fragment into water droplets and spray. This process continues along the leading edge of the wave as it collapses, picking up air until its cascade collides with the water surface or beach, at which point it turns into a maelstrom. When painting this, avoid the temptation of painting it all white. Think of it as having shadows, much like a cloud. Unlike clouds, however, waves have large water globules, spray and confusion of direction: this means that the profile of spray needs more hard and soft edges. Use the surrounding local colour, and those of the sky and light source, to give the spray form.

Mass foam

Mass foam (also called surface foam) is caused by wave action forcing air into the water, which then rises to the surface as bubbles. Areas of mass foam gradually disperse, leaving holes through which the underlying water shows. These can make a good lead-in for the eye towards the point of interest. Highlighting these holes in places that would naturally pick up the sun or moonlight, and shading the opposite side gives the foam an impression of depth and thickness.

Varying the shape and size of patches of foam in a random and natural way will help to give them realistic form and direction.

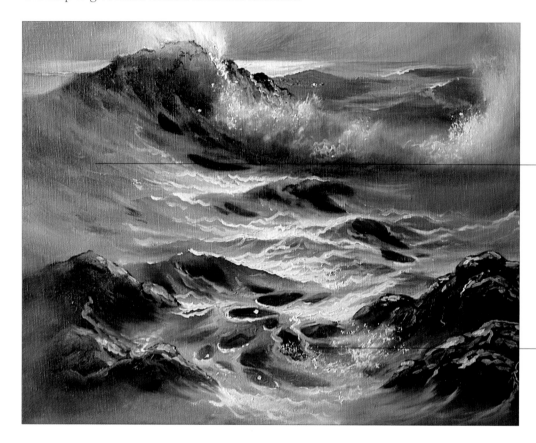

Foam detail from Cornish Moonshine on the Rocks.

Mass foam

Linear foam

Linear foam patterns

Further away from the shore or rocks there will be less foam: only lines or isolated patches remain. These are known as linear patterns and can often be observed where a wave is building up (as it rises, it stretches the foam apart). This is therefore an ideal place to use them to add interest and lead the eye to the wave. They also occur where water is running back off a rock or beach.

Paint linear patterns in various shapes, widths and lengths. Connect some together, divide others and leave spots of foams isolated in clear areas. Do not paint them parallel to each other. In the example shown above, the wave is backlit, so the wave casts a shadow on the foam on its face and near it. The tone of the foam lightens as it comes away from the wave. To add texture and give form to the surface, cut in with the darker tones to create ripples and wavelets. The colours used were the same as those used in the sky (French ultramarine and burnt sienna into titanium white), with the addition of cobalt blue and cerulean blue in places. A minute amount of cadmium yellow pale was mixed into titanium white to highlight the foam.

Tip

Bring attention to the point of interest in your painting by giving it strong tones – dark, light or even a combination of both.

Submerged details

Submerged details add another dimension to water depth. In this detail of *Undertow*, the shallow water has been emphasised by painting in the ripples in the sand. Having painted in the wave with dark blue and green, I started to introduce yellow ochre to show the submerged sand – near the water's edge it is pure yellow ochre. Then using the soft goat hair wash brush I blended these areas in order to get a smooth gradient.

Using the darker tones I painted in the dark shadows of the sand ripples, and in between these I lifted off some of the green/ochre. This created light on each of the ridges. The rocks were then blocked in using French ultramarine and burnt sienna, and their bottom edges hazed out.

Yellow ochre and alizarin crimson into titanium white was used to show the sunlight on the top of the rocks, while to highlight the rock underwater I used phthalo turquoise and sap green into titanium white. Finally, using the darker blue-green mix of the sea, shadows of the foam were painted on to the submerged beach. As the water becomes more shallow, the shadows appear closer to each respective patch of foam.

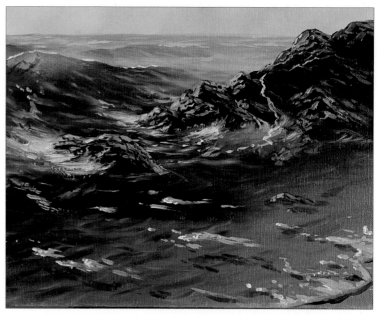

Submerged detail from Undertow.

Shorelines

Shorelines are nigh-on essential to me because they help in composition and are useful in leading the eye around a painting. A distant headland can break up the flat line of a horizon. Rocks give structure, tone and colour to a painting. They also offer the opportunity to create foam bursts and patterns; rock spills and trickles; pools and reflections, and of course create shadows. Distant rocks, in general, should be lighter in tone and cooler in colour than those in the foreground.

Beaches can add colour and allow the use of reflections in wet sand. Most of the time beaches come secondary to the sea in my paintings, but if I want to make more of a feature of them, I give texture to the sand by spattering various thinned-down tones of paint over a general base colour using an old toothbrush and palette knife. Where a wave has expelled its energy on a beach and run back, it leaves a foam scud line. Painted into a beach scene, this adds interest and helps define the dry sand from the wet sand. Remember to give these foam areas light and shade and do not forget that they will cast shadows on to the sand.

Perranuthnoe Sands
560 x 406mm (22 x 16in)

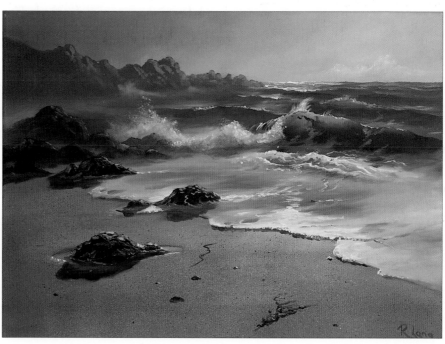

Understanding the sky

The sky not only helps to create the mood of a painting, but also sets the time of day, changes contrasts, alters colours and determines the strength of the light and length of the shadows.

Because water reflects the colours of the sky, skies have a greater influence of colour and tone in a seascape than in a landscape. It is also worth mentioning that there is a constant interaction between sea, land and atmosphere that generates our weather systems (with a little help from other celestial bodies), and that this has a great effect on sea conditions.

Tip

In appearance the sky is generally softer than the sea. Other than in cumulus and thunderhead clouds, you will rarely find hard edges in the sky.

Summer sky

When thinking of a summer sky, most people will instantly think of a clear blue sky with intense French ultramarine overhead, changing to cobalt blue and then the ethereal quality of cerulean blue drawing the eye to the horizon. However, there are many other colours and effects that are just as suitable for summer skies.

In the example below, I have created an atmosphere commonly found on the Cornish coast in the summer, starting with a thick early morning mist which is then burnt off by the heat of the sun. This mist is a sign of the day to come and the promise of a good catch of pilchards for the fishermen, hence the local term that gives the painting its title.

The colours used in the sky run from cadmium yellow into titanium white on the right-hand side; through cerulean blue into cobalt blue on the left. These colours were blended to give the soft, misty effect and painted down to the main wave in the foreground.

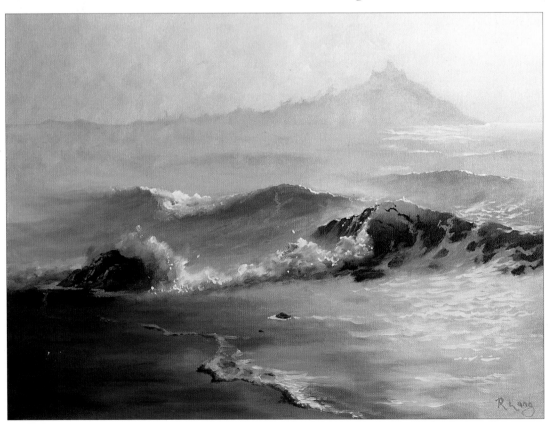

With the sky in place, St Michael's Mount and the background waves were overpainted faintly then blended into the mist with the soft goat hair wash brush.

All for Heat and Pilchards
406 x 305mm (16 x 12in)

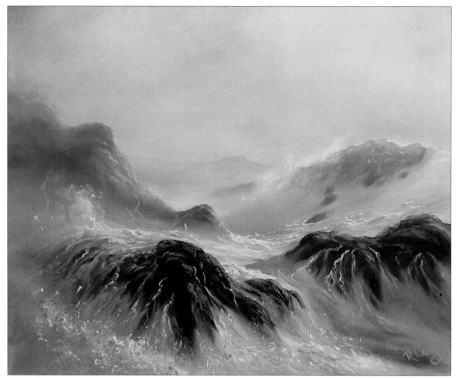

Cloudy sky

In *Storm Surge* (left), a stormy sky was used to set off the turbulent sea, but soft edges and tones ensure that it does not compete with the foreground. Too dark a sky in this painting would have combined with the downward curve between the wave and rocks, and this would have resulted in a generally oppressive scene.

Storm Surge
500 x 400mm (19¾ x 15¾in)

Stormy sky

A dark-toned stormy sky makes a good backdrop to a sea with strong highlighting, as in *Aftermath* on page 13. Placing the cliff and dark cloud next to the sunlit wave makes the paint appear brighter than it is in reality.

In the night scene *Electric Blue* (right), the lightning strike not only sets the storm off, but also gives a source of light in an otherwise dark painting.

Lightning strikes last only a quarter of a second, so I made the highlights appear jagged. I used Prussian blue into titanium white for the strike, the brightest part being the main bolt that has touched down somewhere behind the background swell. 'Spurs' were added in fainter tones coming off the main bolt. Reference material for lightning can be found in libraries or on the internet.

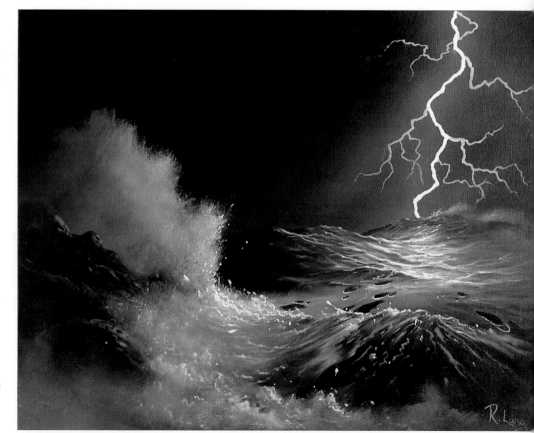

Electric Blue
510 x 406mm (20 x 16in)

Evening sky

Sunsets are both the most colourful and the most challenging skies to paint. The colours and tones have to be well-balanced for an attractive finished painting. For instance, the blues in the upper corners of *Time to Reflect* (below) had to be toned down a little with complementary orange to give contrast against the reds and yellows that gradually blend towards the sun.

I really wanted the brilliance of the sun and its reflection to shine in the sea, so I darkened the sky further by overlaying clouds. You will notice that the clouds are generally much the same tone, but red is added to the areas nearer the sun to emphasise the feeling of warmth in them.

Highlighting adds a three-dimensional look and softness to the clouds, except those adjacent to the sun. Highlights here would be lost and would detract from the strong light behind them. The sky colours were reflected in the wet sands and also at the base of the headland to great effect.

As a word of warning, unless you wish the sky to be the main feature of the picture, avoid intense colours and tones in the sky as these will jump forward in the scene and draw the eye from the sea.

Time to Reflect
560 x 406mm (22 x 16in)

The colours, tones and softened edges convey a feeling of relaxation and contemplation at the end of the day.

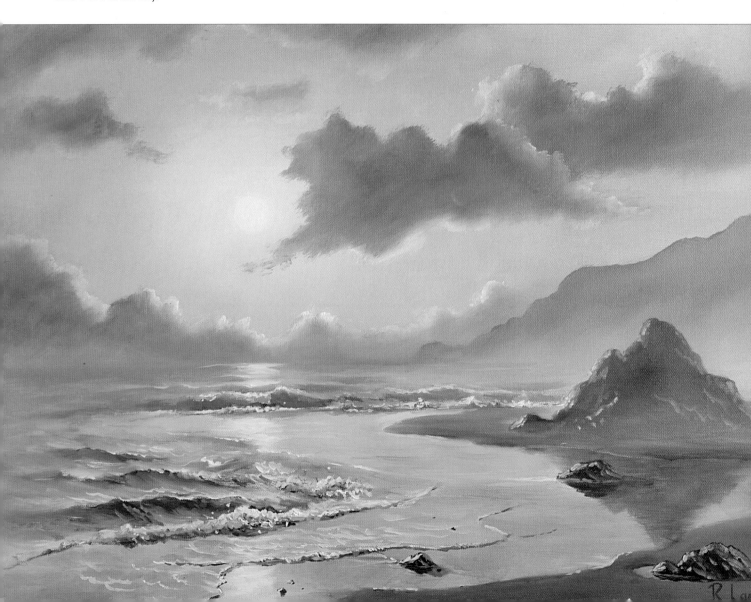

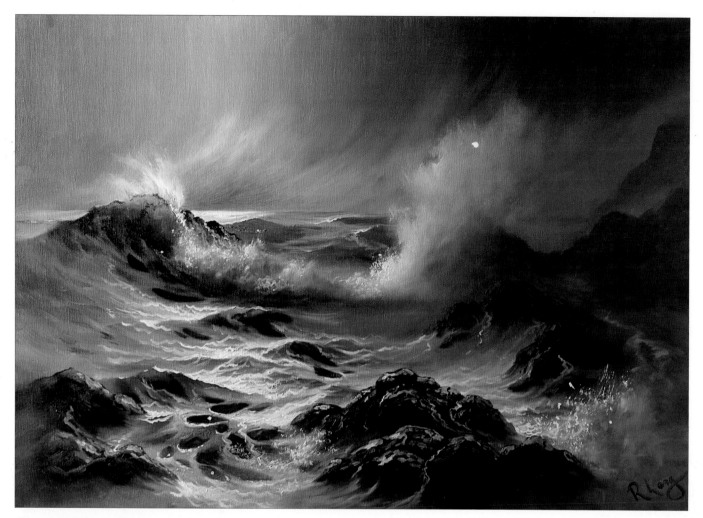

Cornish Moonshine on the Rocks
700 x 500mm (27½ x 19¾in)

Night sky

Now the sun is out of the sky and equation, the number of colours used while painting is drastically reduced, and therefore easier to control. Since the scene will generally be dark (even allowing for moonlight), clouds are not necessary to create contrast. In *Cornish Moonshine on the Rocks* (above), I used a soft fog to add to the composition. This calm sky set off the busy foreground.

The holes in the foreground foam not only give direction to the eye and water movement, but they also contrast well with the moonlight.

Understanding light

Light source

When planning your composition, you should always bear in mind the direction of the light source to maximise the use of shadows. This is particularly important in bright sunlight. Strong light creates well-defined shadows, whereas cloud or mist leads to diffuse or subtle shadows.

Direction of light

Lighting a scene from directly overhead tends to deaden a scene and tones, so avoid this if possible. Back lighting allows the use of light coming through a wave, as shown in this detail from *Spring Tide* (right). Front lighting can be useful if a cliff is behind the view, casting a shadow on the foreground. It can give a spotlight effect on an incoming wave and its foam patterns. Side lighting gives the opportunity to use shadows to their maximum effect.

> ### Tip
> If the sun or moon is to be in view, mask off that part of the canvas with a disc of masking tape prior to painting the sky. When this is removed the moon can be applied to the clean area of canvas without picking up the sky colour.

Detail from Spring Tide.

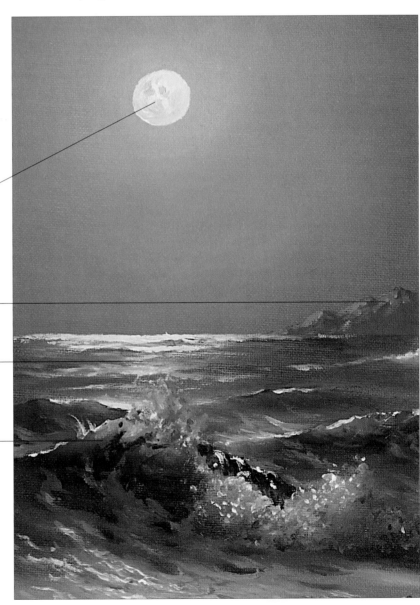

Light source

Direct highlights always face the light source

Moonlight reflected on the sea

Wave is lit from the back

Sunlight

The lightest paint is white, and so to create the brilliance of sunlight on a white surface such as foam, all other areas in a painting should be toned down in relation to it. For instance, in *St Ives Bay* (right), the foam running up the beach was in full sunlight. To darken the blue sea around it I added blue's complementary colour – orange – to tone it down. As an aside, I could also have replaced the complementary colour with Payne's grey to mute the colour and achieve a very similar effect.

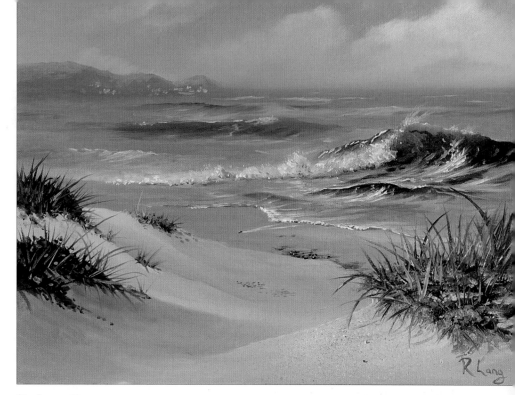

St Ives Bay
406 x 305mm (16 x 12in)

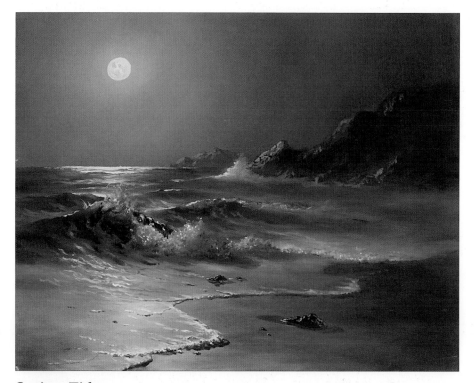

Spring Tide
558 x 406mm (22 x 16in)

Moonlight

Night scenes are the best for the newcomer to seascapes because they are far easier to control than day or sunset seascapes, as the reflected colours are easier to portray.

When painting moonlit scenes, I use the same palette of colours as usual, but I tend to use more French ultramarine and burnt sienna. Moonlight can heighten the sense of romance and mystery in a view.

Reflected light

Remember that reflected light illuminates shadow areas and brings them alive, but keep the shadow edge dark – as discussed in the section on tone (pages 12–13), the darkest shade should be next to the lightest tint.

Reflections

Reflections are another important part of painting seas and skies in oils, appearing not only in the sea but in wet sand, pools of water and so forth.

In calm water, reflections occur directly below their objects, and in mirror image. It is a good point to remember that in calm water reflections are well-defined, but become increasingly diffused as the water surface gets rougher. Reflections on calm water also appear stronger as the angle becomes greater between an object and the viewer's eye, but less intense as the angle decreases. The reason for this is that more of the light from the image is lost into the water, reducing the amount of light being reflected back up into the eye. In addition, the visual information from below the water's surface increases and therefore competes for attention.

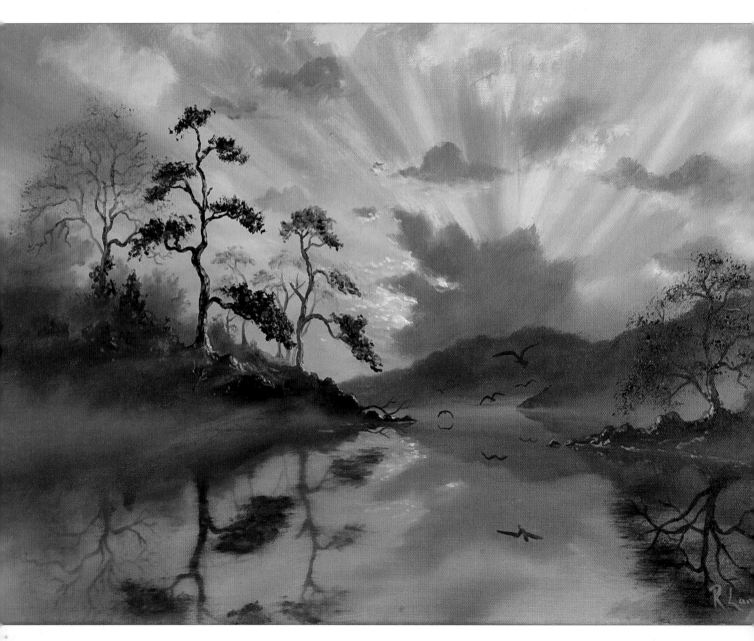

SHADOWS AND REFLECTIONS

Be careful not to confuse shadows with reflections, particularly in the case of side lighting where the shadow will occur on the opposite side of the object, but the reflection will still appear below it.

REFLECTED COLOURS AND TONES

Both colours and tones will appear different in an object and its reflection. Colours are more muted in reflections than in objects, while the tones in reflections tend towards mid-tones, with dark-toned objects appearing slightly lighter and light-toned objects becoming darker.

Tip

Avoid scenes where reflections will over-complicate your painting.

Detail from Time to Reflect.

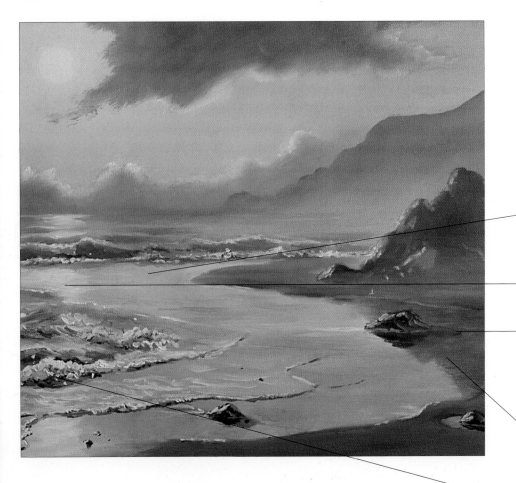

The colours of the sky are muted in the reflection

Reflection in wet sand

This shadow is behind the rock, but the reflection of the rock remains below it

The tones of the dark rocks appear lighter in their reflection

Turbulent water disrupts the reflections

Opposite:

First Light at Gillian Creek
559 x 406mm (22 x 16in)

In this painting the reflections of the trees are softer in tone than the trees themselves. Note also that the more distant the object from the viewer, the softer the reflection. Compare the foreground firs' reflections to the reflections of the trees in the middle distance. The reflections (particularly those of tree branches) may alter slightly due to their angles, and to inaccuracies in portraying them. They are therefore best painted from life (or reference material close at hand). Try to sketch the reflections first, as you may soon miss them if the tide goes out while painting.

Mood and atmosphere

Most subjects and portrayals of them in oils can be said to have mood and atmosphere, and the words are particularly apt when used to describe the sea and sky. Each has a great effect on the other, and this can result in rapid and evident change in the overall view.

When considering mood and atmosphere in your composition, take into account colours and tone. Experiment with gentle beaches, soft sands, tempestuous seas, sharp unforgiving rocks, lightning, threatening skies, mysterious fogs, inviting blue skies, warm sunsets and romantic nights.

Each of these ideas can be combined with others to evoke a particular feeling in the mind of the viewer: awe, exhilaration, melancholia, tranquillity or anything you like.

Observation and painting skills are a big factor in achieving mood and atmosphere, and knowledge of the subject certainly helps. I believe that having a passion for your subject is essential – if you have that passion, it will shine through in your paintings and give them that elusive, expressive quality that will speak volumes about mood and atmosphere.

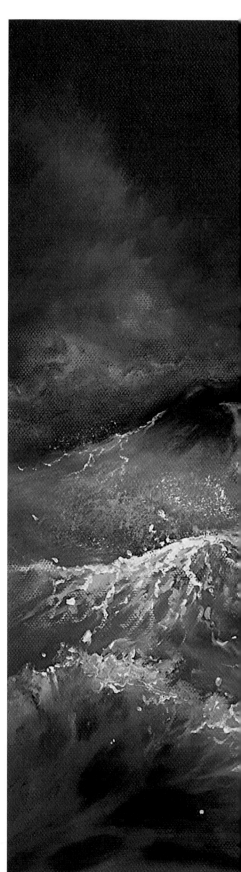

North Cliff Breakers
406 x 305mm (16 x 12in)

This scene was painted on the north Cornish coast with the cliffs casting shadow over the majority of the scene, hence its dark tones. The sunlight cutting through a cleft in the cliffs spotlights the major wave, the water spill-offs and the central rocks. The misting at the foot of the cliffs gives softness against the turmoil in the foreground. The major colours in the dark areas are French ultramarine and burnt sienna with alizarin crimson and yellow ochre. The sky colours are titanium white, cobalt blue, cerulean blue and a touch of alizarin crimson for warmth.

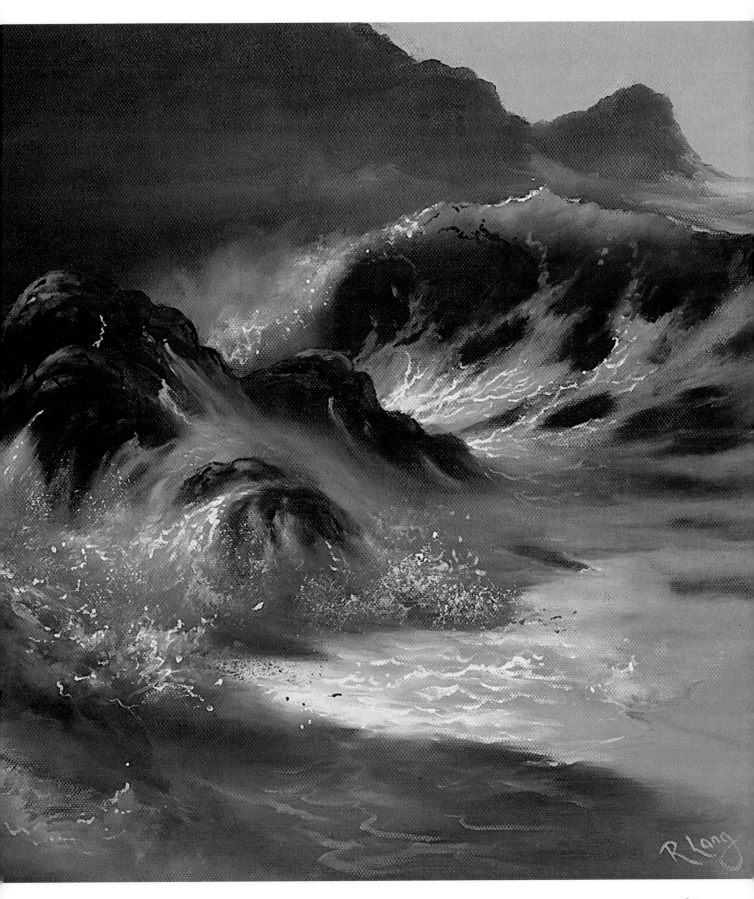

Ebb Tide

With this painting I wanted to capture the exhilarating freshness of a beach newly uncovered by the receding tide, and evoke the salty smell of a beach after rainfall; perfect for clearing the mind – and your nostrils!

The composition of the painting leads the eye to the main wave and entices the viewer to wander down the beach to the sea.

You will need

Sketch pad

HB pencil

Canvas board, 508 x 406mm (20 x 16in)

Masking tape

Palette

White spirit and cleaning rag

Kitchen paper

Palette knife

Brushes:

Size 00 sable, size 2 round, size 6 round, size 2 flat, size 4 filbert, size 6 filbert, 22mm (⁷/₈ in) goat hair wash brush, cheap bristle brush

Paints:

French ultramarine, cadmium yellow pale, alizarin crimson, titanium white, cobalt blue, cerulean blue, burnt sienna, yellow ochre, sap green

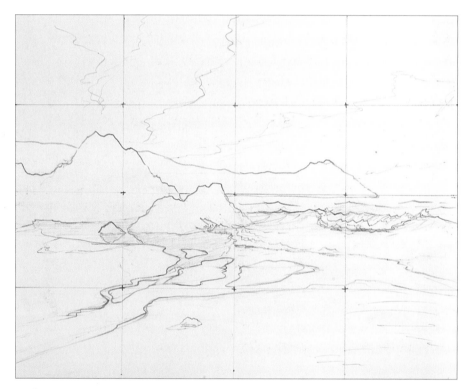

1. Sketch out the composition in your pad, and draw a grid of sixteen equal squares across it.

2. Divide your board into sixteen squares, and then work square by square to transfer your sketch to the board, using the HB pencil.

3. Use masking tape on the sea, so that the top edge is on the horizon line. This will keep the horizon clean and level, and make it easier to block in the sea later.

4. Mix a neutral grey from French ultramarine, cadmium yellow pale and alizarin crimson. Add titanium white, French ultramarine and cobalt blue to this for the sky mix. Scrub this mix into the sky area with the size 6 round brush, working from the top downwards with a scrubbing motion to work it into the weave.

5. Add cerulean blue to titanium white, then paint in the lower area of the sky. Lighten the sky towards the right-hand side of the painting by mixing more titanium white directly on to the board.

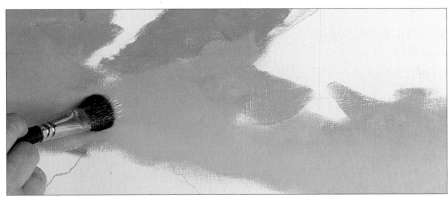

6. Add cobalt blue to this mix and add a mid-tone to the sky between the two colours already on the board. Again, add a little more titanium white to the mix on the right-hand side. Use the goat hair wash brush to blend the colours in the sky into one another.

Tip

Mix a fairly large amount of each of the main colours and save part of each one. Using the same colours throughout the work helps to tie the finished painting together.

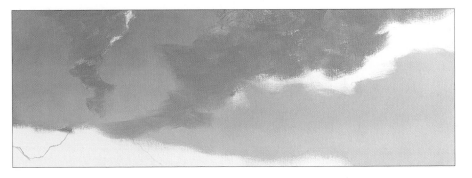

7. Start adding clouds with a mix of titanium white, French ultramarine, alizarin crimson and yellow ochre. Block them in with the size 6 filbert, scrubbing the colour into the canvas, leaving bare canvas showing on the right of the clouds.

8. Switch to the size 4 filbert, and highlight the clouds using titanium white with a drop of cadmium yellow pale added.

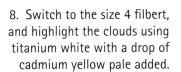

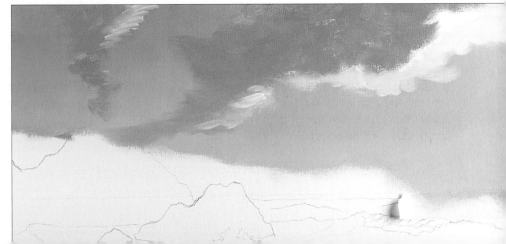

9. Add alizarin crimson to this cloud highlight mix and scrub this pink mix on to the clouds between the highlights and main colour.

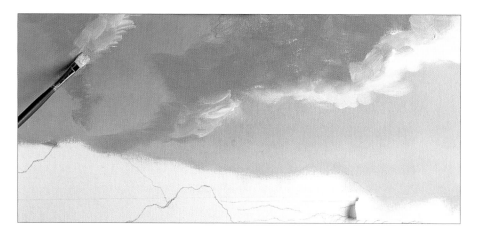

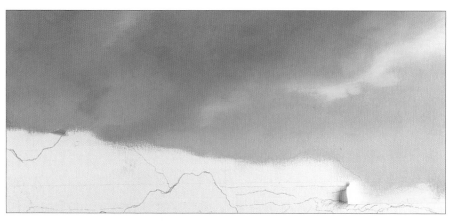

10. Blend the cloud colours into one another using the goat hair wash brush.

11. Use the size 6 filbert to block in the headland using a mix of titanium white, French ultramarine, cobalt blue, alizarin crimson and a touch of burnt sienna. Keep the edge sharp at the top by turning the brush as you pull it across the board, as shown in the inset. Tidy up the paint with the size 2 flat brush and remove the masking tape.

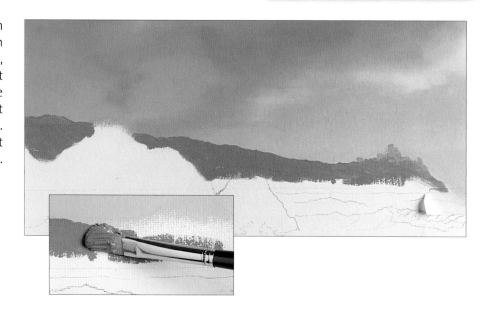

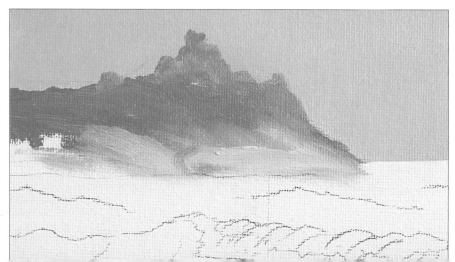

12. Use the cloud highlight mix to paint in the misting below the outcrop on the far right of the headland.

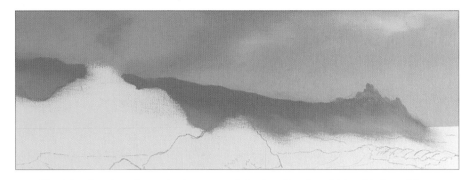

13. Block in the sky mix at the bottom of the headland and blend it in, with a very light touch to ensure the headland colour does not muddy the misty effect. Notice how this makes the colours recede. Blend with brushstrokes going up the hill to suggest the spray wafting up the cliff.

14. Make a strong mix of titanium white, French ultramarine, cobalt blue, alizarin crimson and a drop of burnt sienna. Use this to block in the rocky outcrop in the middle distance, rolling the brush to get a sharp edge.

15. Blend the headland mix into the bottom of the outcrop for a soft, misty effect.

16. As we advance into the picture, we need to start adding reflected highlights from the sky. Add yellow ochre to the headland mix, and add this to the edge of the outcrop where the sunlight catches it, using the size 6 round brush.

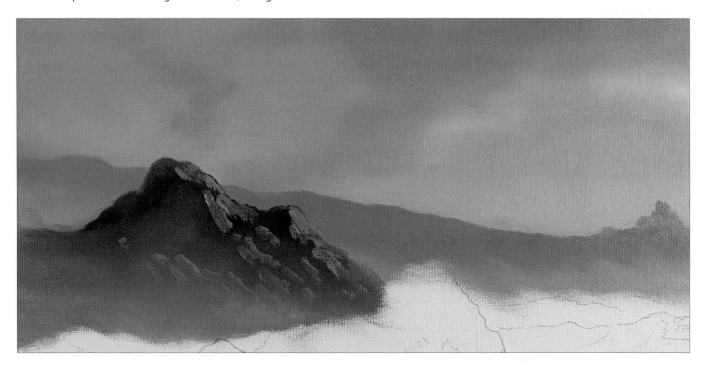

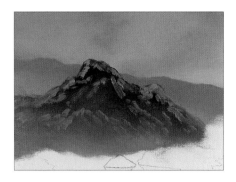

17. Add reflected light on the left-hand side of the outcrop using the original sky mix, and blend these highlights into the main colour, particularly at the bottom of the outcrop, to represent misting.

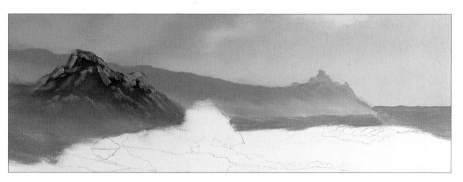

18. Use the size 4 filbert to draw the misting effect on the outcrop further down the board, then make a sea colour by mixing titanium white, French ultramarine, cobalt blue, a drop of burnt sienna and a spot of sap green. Paint in the sea on the horizon line using the size 6 filbert, and draw it down to the top of the main wave and along the bottom of the headland.

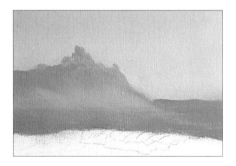

19. Tidy the edges with the size 4 filbert, and then blend and soften until any hard lines are lost.

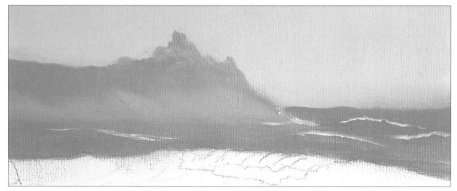

20. Add titanium white, a drop of cadmium yellow pale and a touch of alizarin crimson to the sky mix, and use this to highlight the edges of some of the background waves.

21. The troughs of the waves catch the light and reflect the sky, so use the sky colour to paint reflections on the sea. Start above each of the waves, blending them slightly. Use long, curving strokes of the size 00 sable to suggest the shapes of the waves. Use the pale blue-grey to suggest more disturbances at the bottom of the cliff, then blend these stages slightly.

22. Add more French ultramarine, burnt sienna and sap green to part of the sea mix for the foreground wave. Paint around the foam pattern and up either side using the size 4 filbert.

23. Add cerulean blue and titanium white to the original sea mix and use this to paint the fold where the wave is coming over, using a size 2 round brush. Blend some of the foreground wave mix into this area.

24. Mix titanium white, cadmium yellow pale and sap green and use this mix to paint the sides of the wave to represent the sun shining through the water.

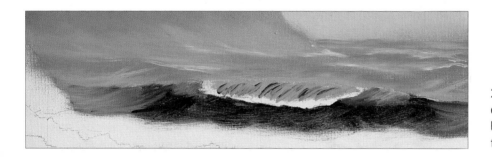

25. Add a touch of the sky mix to either end of the wave, keeping the brushstrokes following the water from the surface to the crest of the wave.

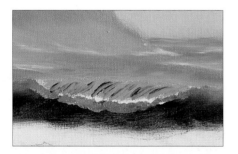

26. Blend the front of the wave using the small cheap bristle brush, and use the sky mix to paint underneath the foam burst with the size 2 round brush.

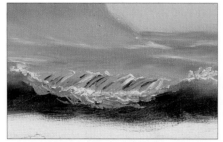

27. Use the cloud highlight yellow mix to highlight the wave along the crest and along the top edge of the foam burst. Pick out extreme highlights on the top of the wave, and use the same mix for some spray.

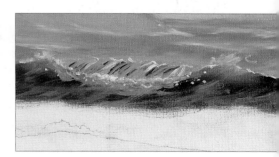

28. Suggest foam patterns with the darker sky colour on the front of the wave to help give it shape and form. Soften this a little and dot in loose spray with the cloud highlight yellow mix.

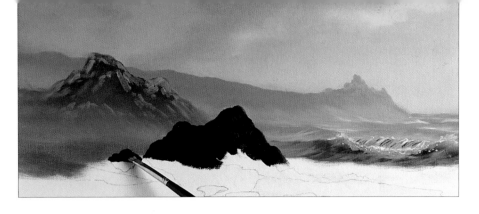

29. Use the main wave mix to block in the beach on the left, then paint in the central rock using a mix of French ultramarine and burnt sienna with the size 4 filbert. Roll the brush (see page 14) for sharp edges on the rock.

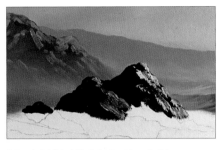

30. Add highlights to the right-hand sides of the rock with the size 2 flat brush and a mix of titanium white, yellow ochre and a touch of alizarin crimson.

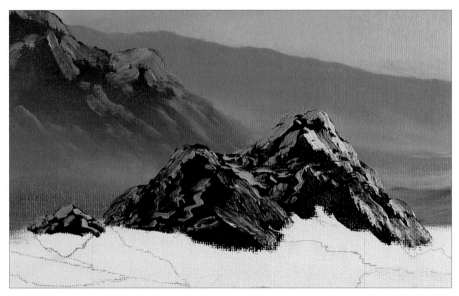

31. Use the darker sky colour for reflected light on the left-hand sides of the rocks, then add zig-zag lines with the size 00 sable brush to add interest.

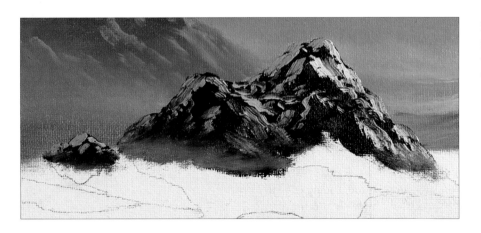

32. Use the rocky outcrop colour for a little misting around the base of the rocks to soften the hard lines at the base.

33. Use the rock colour to add in some more cracks and crevices in the rocks. Paint in the shallow waters and the slick areas around the wet beach with the size 6 filbert brush. As the water advances, darken the mix, mirroring the gradient of colour in the sky. Use the cloud highlight on the far right, again mirroring the sky.

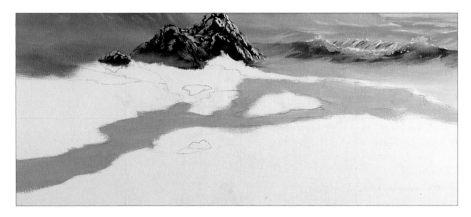

34. Mix the rocky outcrop colour with the sky mix and foreground rock mix and lay in the reflection of the outcrop and foreground rock with the size 2 flat brush. Follow the contours of the dryer sand, and be careful not to overlap the wave breaking on the rock. Add some of the cloud highlight mix to bring the reflection out a little.

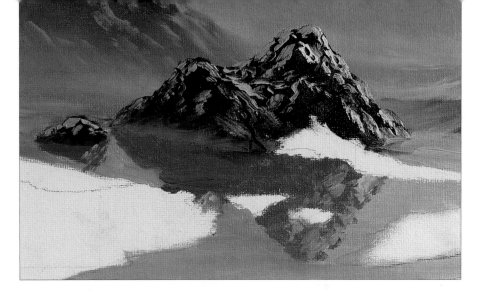

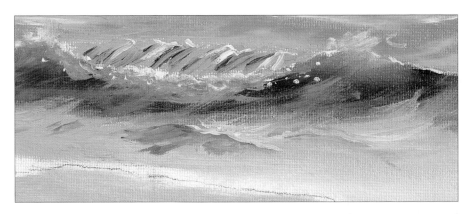

35. Mix the darker sky colour with the green wave mix and paint some ripples in front of the completed wave. Emphasise these with the cloud highlight mix.

36. Add cobalt blue and alizarin crimson to the dark sky mix and paint this mix along the shallow edge of the water lapping up the wet beach. Use the same mix for the expiring wave on the right and the foam burst on the foreground rock.

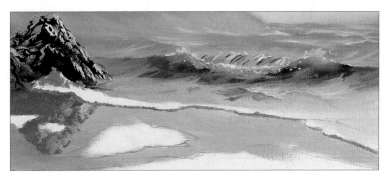

37. Highlight the scud line with the lighter sky mix, paying particular attention to the foam burst around the rock. Blend the cloud highlight in with the goat hair brush, and drag it down with a size 2 round brush to texture the leading edge of the scud line. Use titanium white on its own to add bright highlights to the area, dotting it on with the size 2 round.

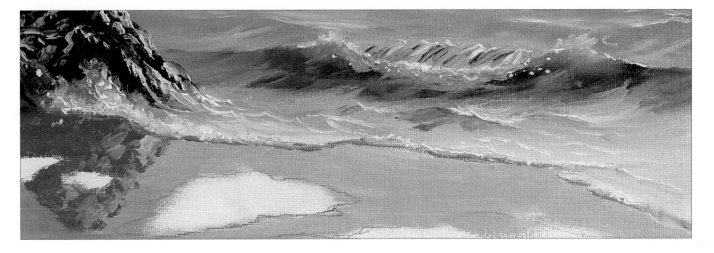

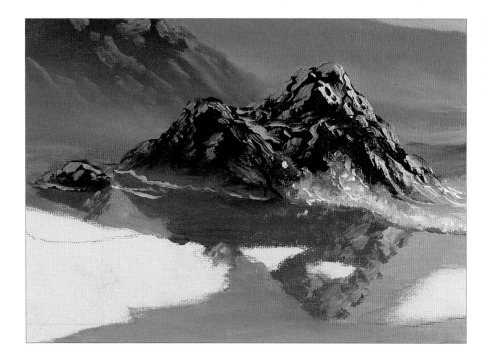

38. Use the sky mix to define a line between the rock and its reflection, and add foam running back to the right of the rocks, following the retreating water.

39. Mix titanium white, French ultramarine, cobalt blue, sap green, yellow ochre and the rock mix for a grey-green beach mix, and paint in the sandy areas with horizontal strokes of the size 6 filbert. Fade the sand towards the edges of the painting.

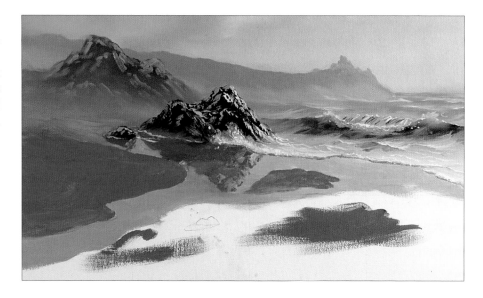

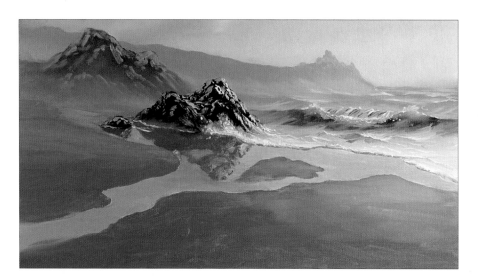

40. Add yellow ochre and titanium white to the mix to vary the tone as you work towards the bottom of the painting. Suggest reflections of the cloud in the wetter areas of the beach, and blend the reflected sky colours into the wet sand.

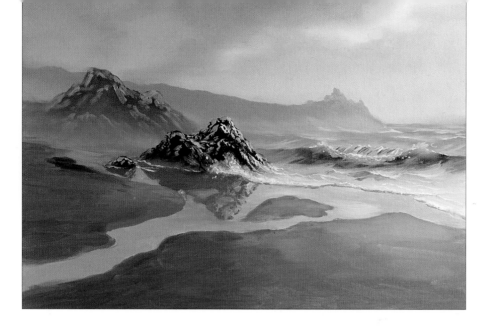

41. Use the goat hair wash brush to blend and soften the beach, to ensure the sand and water are not starkly separated.

42. Highlight the beach on the right using a mix of titanium white and yellow ochre with a hint of alizarin crimson.

43. Paint the areas where the sand is eroded and catches the light with a stronger mix of the same colours. Use the rock mix to pick out the shade on the opposite shore.

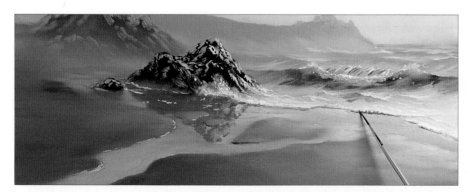

44. Switch to the size 2 round brush and use the paler sky mix to paint some areas of foam trailing across the reflections of the rocks. Use the same mix for some subtle lines on the water for added texture and interest.

Tip

Spattering can be very messy, so be gentle and keep the toothbrush a good distance away from any areas you do not want spattered.

45. Combine the rocky outcrop and foreground rock mixes, and thin the mix down with white spirit to the consistency of single cream. Spatter this mix over the foreground beach, following the instructions on page 18.

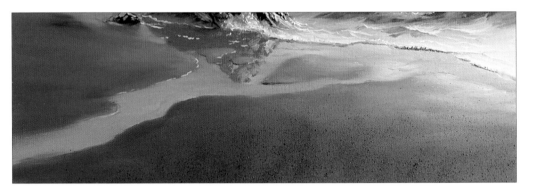

46. Thin the rocky outcrop colour and spatter it on to the closest area of beach, as before. Make sure that you clean and dry the brushes you use thoroughly to make sure that no white spirit pollutes the painting.

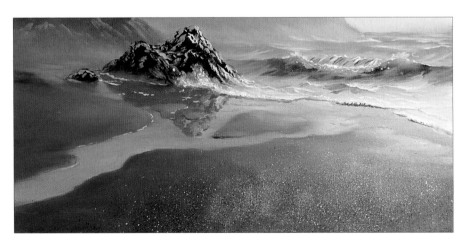

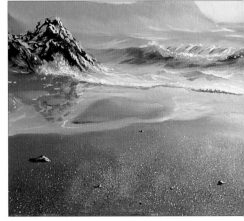

47 . Repeat the spattering technique with the sky highlight mix, and then repeat once more with thinned titanium white for the final highlight.

48. To complete the picture, add a few pebbles using the same colours and techniques for the foreground rocks; and some pure titanium white ripples in the foreground water.

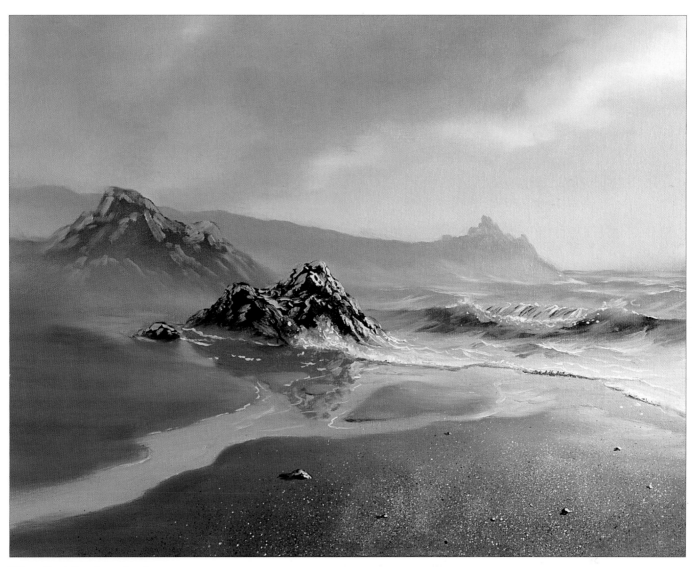

The finished painting
508 x 406mm (20 x 16in)

The plain beach gives this scene a calming effect. It makes it uncomplicated to paint and relaxing to look at.

Passing Squall

In this painting, I wanted to show strong associations between the weather and the state of the sea. For this reason I have given little under half of the canvas to the sky and storm cloud. The squall's promise to be brief is shown by the clear blue cerulean sky beyond, and this stops the scene becoming too full of foreboding.

I have incorporated the 'S' (see page 20) along the top half of the cloud down to the wave, which then runs up the gully and finally across the foreground.

You will need

HB pencil
Canvas board 508 x 406mm (20 x 16in)
Masking tape
Palette
White spirit and cleaning rag
Kitchen roll
Palette knife
Brushes:

Size 00 sable, size 2 round, size 6 round, size 2 flat, size 4 filbert, size 6 filbert, 22mm (⁷⁄₈in) goat hair wash brush, cheap bristle brush

Paints:

Cobalt blue, French ultramarine, titanium white, alizarin crimson, cerulean blue, yellow ochre, cadmium yellow pale, burnt sienna, sap green

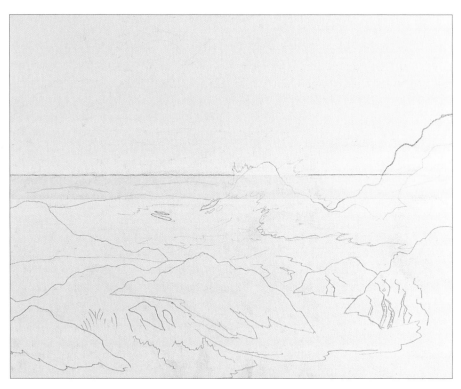

1. Sketch out the picture directly on to the board with an HB pencil. Lay a strip of masking tape across the horizon, below the level of the sea.

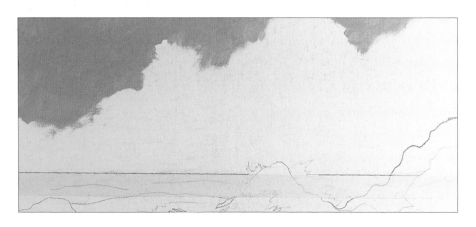

2. Make a clear sky mix from cobalt blue, French ultramarine, titanium white and a touch of alizarin crimson. Use the size 6 filbert to block in the top of the sky, using figure-of-eight strokes to force the paint into the grains of the board, and starting to form the outline of the clouds.

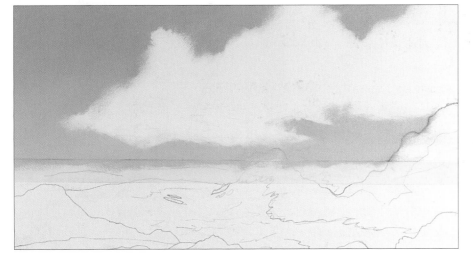

Tip

Fading the strength and detail at the edges of the picture helps to make the central area the focus, and stops a viewer's eye drifting out of the painting.

3. Add cerulean blue and more titanium white to the mix and scrub in the area near the horizon. Use the goat hair wash brush to blend the colours together.

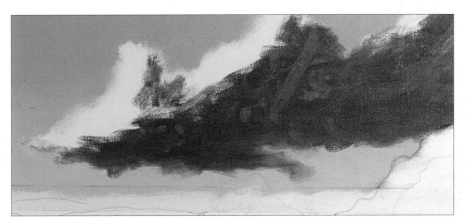

4. Mix a blue-grey from titanium white, French ultramarine, cobalt blue, yellow ochre and alizarin crimson for the dark cloud. Using the size 6 filbert, scrub the mix on vigorously, using rough, uneven brushstrokes for a stormy pattern.

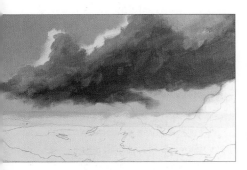

5. Add more titanium white to this mix and paint in the lighter mid-tones of the cloud.

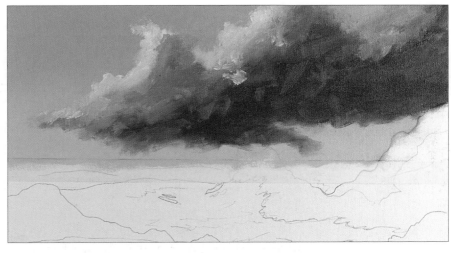

6. Add a touch of cadmium yellow pale and yellow ochre to titanium white, and use this mix to paint the cloud highlights.

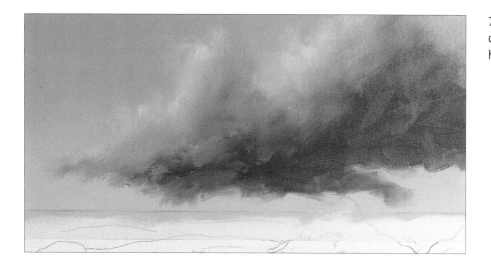

7. Soften any hard edges in the cloud highlights using the soft goat hair brush.

8. Reintroduce some of the dark cloud colour into the shaded area with the soft goat hair brush. The soft hairs of this brush make it easy to control and give a subtle, soft feel to the painting.

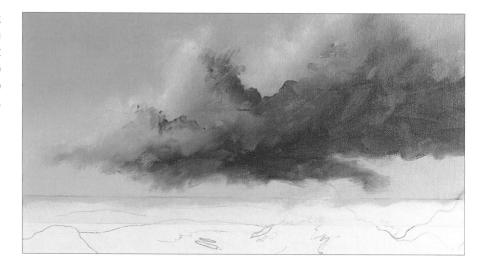

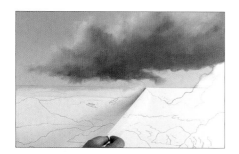

9. Again, use the soft goat hair brush to blend away any hard edges, then peel off the masking tape.

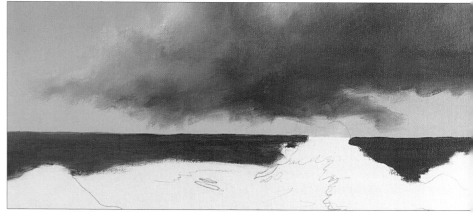

10. Make a sea mix by adding French ultramarine to the cloud shadow mix, and use the size 6 filbert to block in the background sea, using horizontal strokes to paint in the sea up to the horizon.

11. Use the clear sky mix to paint reflections on to the sea near the horizon. Use long straight strokes with the size 2 round brush.

Tip

Remember that the waves in the water should appear to be closer together nearer the horizon, becoming more spaced apart as they approach the foreground.

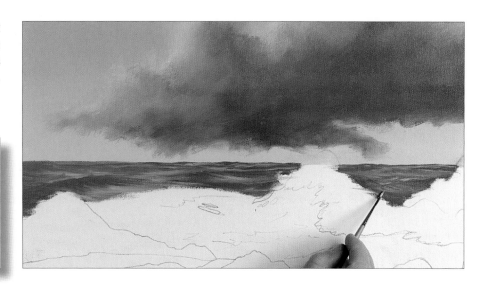

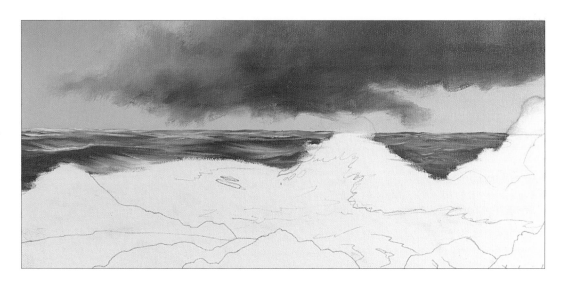

12. Use the horizon sky mix to highlight the reflections, and then the cloud highlight to suggest reflected sunlight on the extreme left.

13. Load the bristle brush with the dark cloud mix, and draw it sharply and quickly downwards from the cloud to suggest rainfall. Keep the rain at a constant angle. This ensures a realistic look and gives some dynamism to the effect.

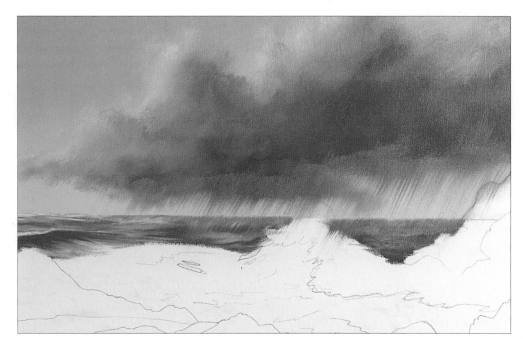

14. Soften the rain with the goat hair wash brush, paying particular attention to the right-hand side, and working in the same direction as the rainfall. Blend any brushstrokes out of the cloud.

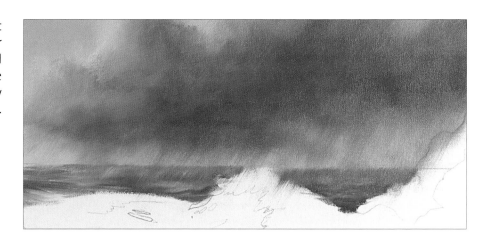

15. Add French ultramarine and a touch of burnt sienna to the sea mix and use the size 4 filbert to paint holes in the foam pattern. This will help define clear areas in the foreground wave later.

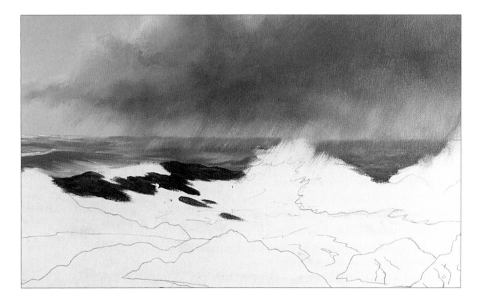

16. Blend pure sap green into the white space at the top of the wave to show light coming through the water.

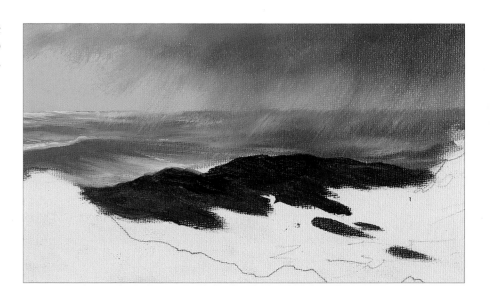

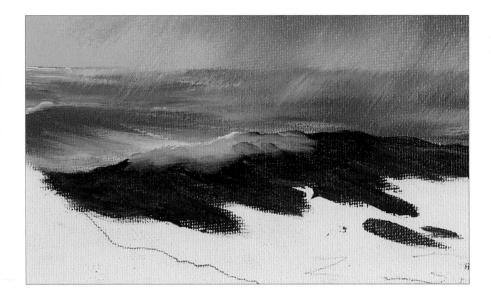

17. Mix cadmium yellow pale into titanium white and blend this mix into the tip of the wave.

18. Blend from the crest of the wave down using the cheap bristle brush. Add shading to the wave crest with sap green added to French ultramarine with a touch of burnt sienna. Follow this with a sharp highlight made up of a mix of cadmium yellow pale, yellow ochre and titanium white.

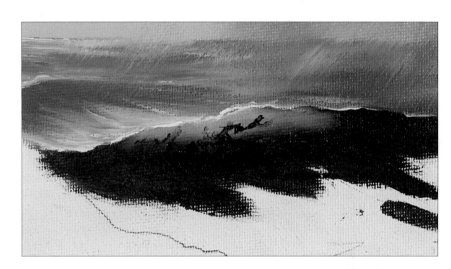

19. Combine the sea and wave mix to reintroduce waves in the middle distance to drop the rain effect back.

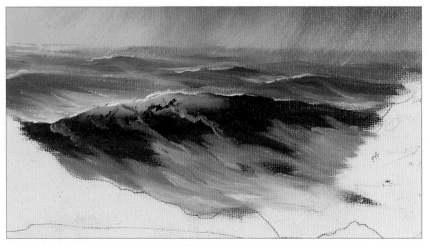

20. Darken the sky mix with cobalt blue, French ultramarine and alizarin crimson, and use the size 6 filbert to paint the foam patterns on the front of the foreground wave. These colours are then highlighted with cadmium yellow pale into titanium white, and blended in the direction of the curve of the wave.

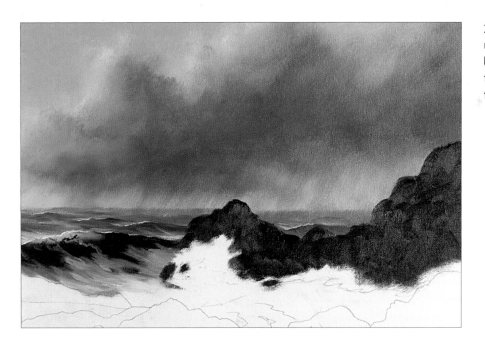

21. Mix a cool grey from French ultramarine with a smaller amount of burnt sienna. Add some sky mix and a touch of alizarin crimson, and paint in the rocks on the centre and right.

22. Use a size 2 round brush and a mix of French ultramarine, burnt sienna and sap green for the breaking wave, then add cerulean blue to the mix and paint the water beneath the rocks. Leave some of the bare white board showing through.

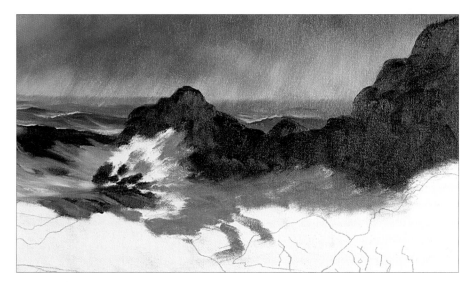

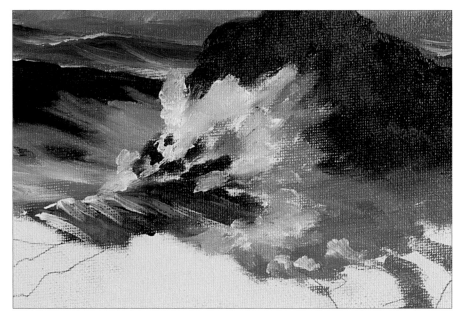

23. Blend pure titanium white into the foam burst to highlight. Scrub the paint in thickly with the size 4 filbert, then switch to the size 00 sable to highlight the wave roll.

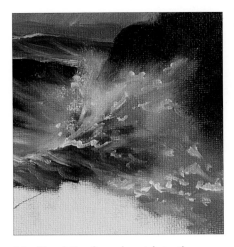

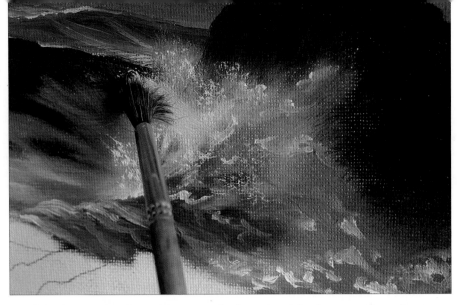

24. Blend the foam burst into the rocks, following the direction of the water to give a sense of movement. The blending will blur the foam burst, so add new highlights with the size 00 sable. Continue blending the thrown spray into the rocks.

25. Stipple pure titanium white on to the foam burst for thrown spray, using the size 6 round. Remember, not all of the energy of the wave will be forwards, so dab some spray thrown backwards.

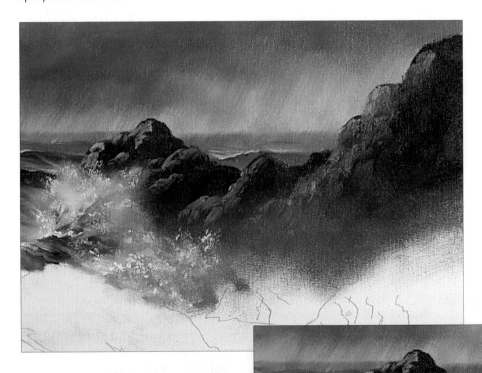

26. Add yellow ochre to the sky mix, and use the size 2 flat to roll highlights on the left-hand sides of the rocks. Use gentle, broken strokes to separate and define the rocks.

27. Use the sea colour to paint the mist around the base of the rock, adding trickles and run-off to show the water cascading off the rocks. Blend these in gently with the goat hair wash brush.

28. Add more cobalt blue and French ultramarine to the rock mix, and use this to paint in the large rock on the left and the smaller rock on the right using the size 6 filbert.

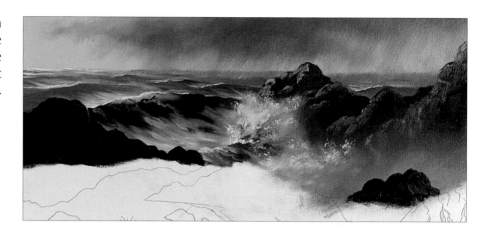

29. Use the rock highlight mix to accentuate the rock on the right, and add a little more titanium white for the left-hand rock. Note the 'S' shape that has begun to form in the picture.

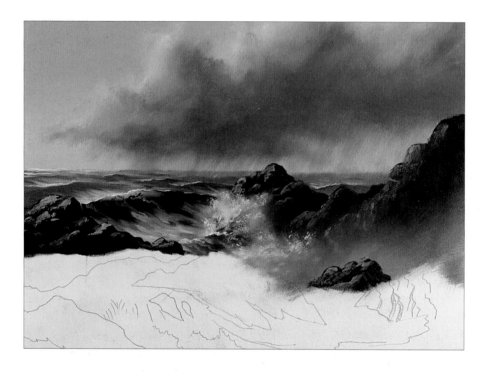

30. Add reflected light on the right-hand sides of the rocks using the sky mixes. Use faint tones on the background rocks, and stronger ones on the foreground rocks.

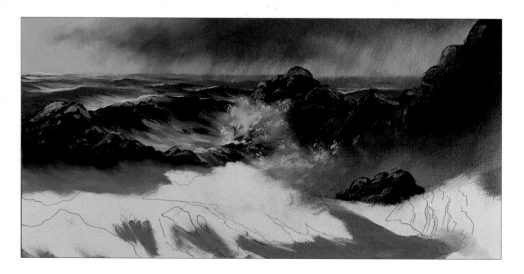

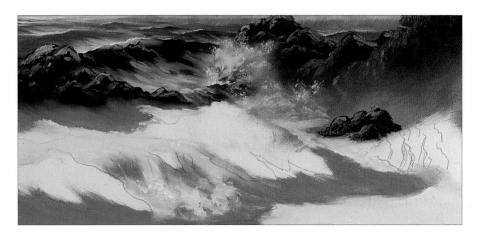

31. Paint the water at the bottom of the painting with a mix of titanium white, French ultramarine, cobalt blue, yellow ochre and alizarin crimson, following the direction of the water. Add a touch of cadmium yellow pale to titanium white for a foam mix, and roughly paint areas of foam around the closest rocks before blending these in with the goat hair wash brush.

32. Add more cerulean blue to the horizon sky mix, and paint in a cascade of water from the rock on the left-hand side. Blend this in, and add a few highlights with the sky mix. Use the same colour to add some trickles on the rocks.

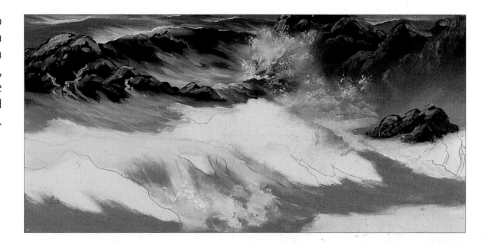

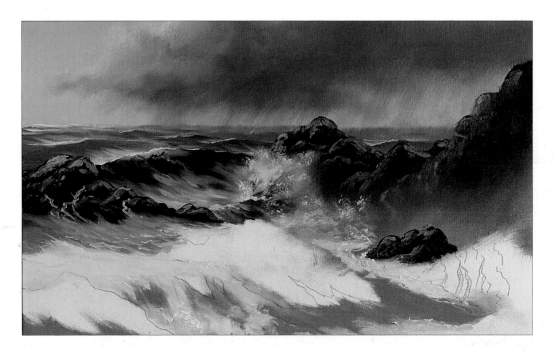

33. Overlay the foam mix around the cascade in the centre (below the foam burst on the central rock) and also by the rock on the right-hand side. Feather the foam on the bottom right as well, in order to further blend the colours together and give a sense of mist.

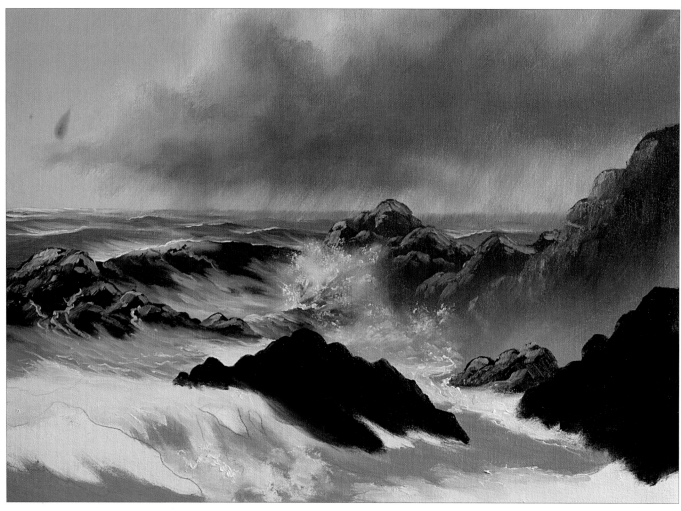

34. Darken the rock colour by adding more cobalt blue and French ultramarine, and paint the rock on the far right. Adding burnt sienna to this mix to warm it a little, block in the central rock. Use the size 6 filbert but switch to the size 2 round at the bottom to avoid muddying the foam.

35. Add yellow ochre to warm the rock highlight mix and highlight the rock on the bottom right. Aim for a stepped effect as shown by keeping the highlights stark and sharp.

36. Use the dark sky mix to cut in on the rock and add reflected light on the very bottom right.

37. Use the cloud shadow mix to add reflected light on the right-hand side of the central rock.

38. Mix alizarin crimson and cadmium yellow pale into titanium white and use this mix to paint the direct highlights on the left-hand side of the rock.

39. Mix cerulean blue, sap green and titanium white, and touch in the light reflected off the foam on the right-hand side of the rock. Use the rock mix with the size 00 sable to suggest texture on the rock.

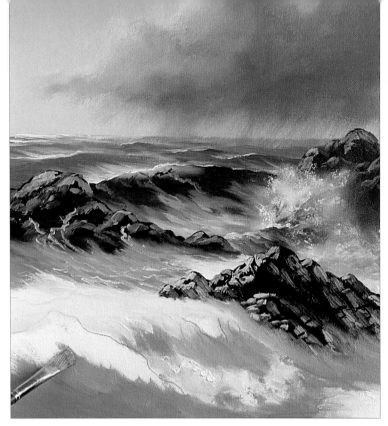

40. Use a mix of cerulean blue and titanium white to paint aerated water at the base of the central rock, and at the bottom left of the painting.

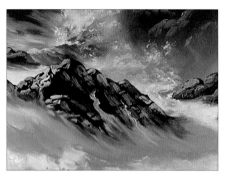

41. Mix titanium white and the sky mix, and paint trickles running down the right-hand side of the rock. Blend these into the sea at the bottom.

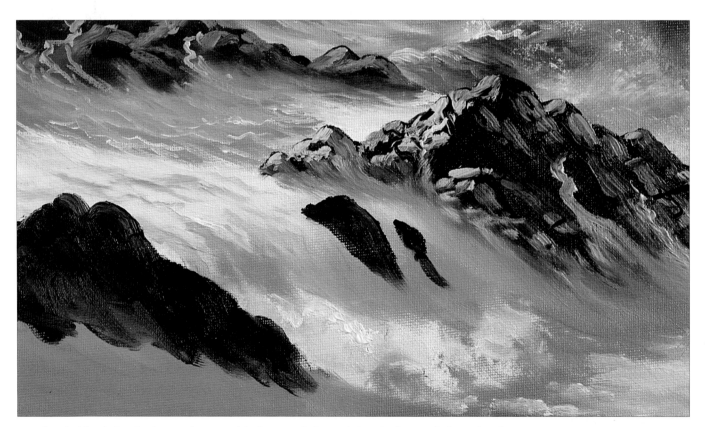

42. Gently blend the ripples on the sea with the goat hair wash brush, then switch to the size 4 filbert and add the large rock on the bottom left using the rock mix. Switch to the size 2 round and place the small rocks to the right of the new rock.

43. Gently blend the paint at the bottom of the rocks into the sea, then highlight the new rocks, using the rock highlight mix used in step 39. Use a stronger mix, with more alizarin crimson and cadmium yellow pale, for the smaller rocks.

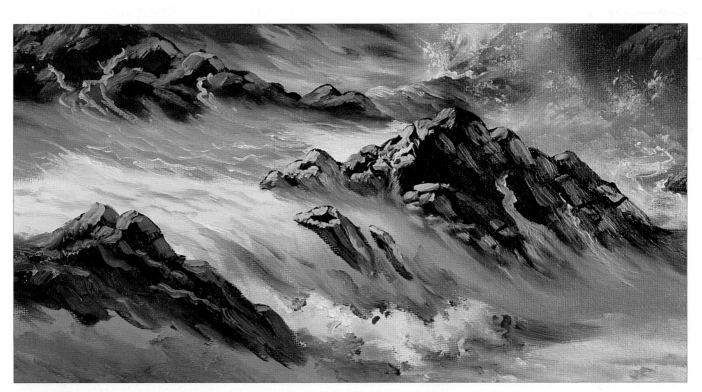

44. Add the reflected highlights with the dark cloud mix, overlaying these on the smaller rocks with the foam highlight. Then add French ultramarine and alizarin crimson to the sky mix for a warm purple, and dab around the bottom of the painting for the darkest shades of the sea. Drag these shades up the cascade to remove any hard edges.

45. Use a mix of cerulean blue, sap green and a little titanium white to suggest the tips of submerged rocks in the cascade, and highlight them by adding a small 'collar' of white fading to a cerulean blue and titanium white mix.

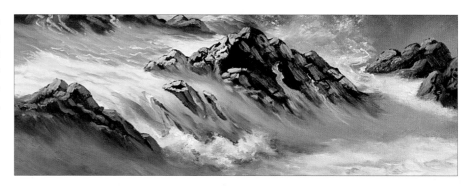

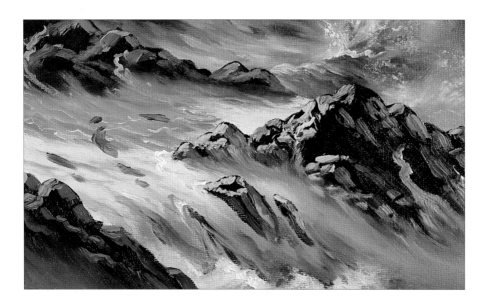

46. Create some holes in the foam pattern using a mix of the sky colour with cobalt blue and the dark cloud mix added. Add yellow ochre to the mix for the holes out of the shadow.

47. Use the cheap bristle brush to stipple white around the cascade area, then soften the effect with the goat hair wash brush. Use the size 00 sable to paint slightly larger white areas of spray to suggest movement. Add some small French ultramarine dots to contrast with the white.

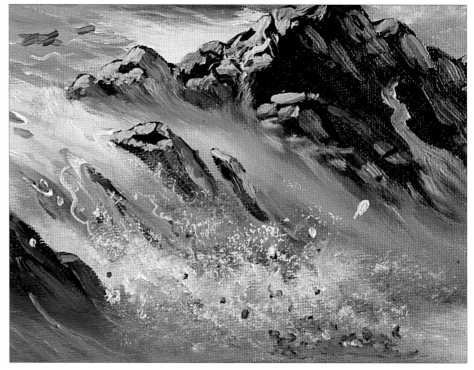

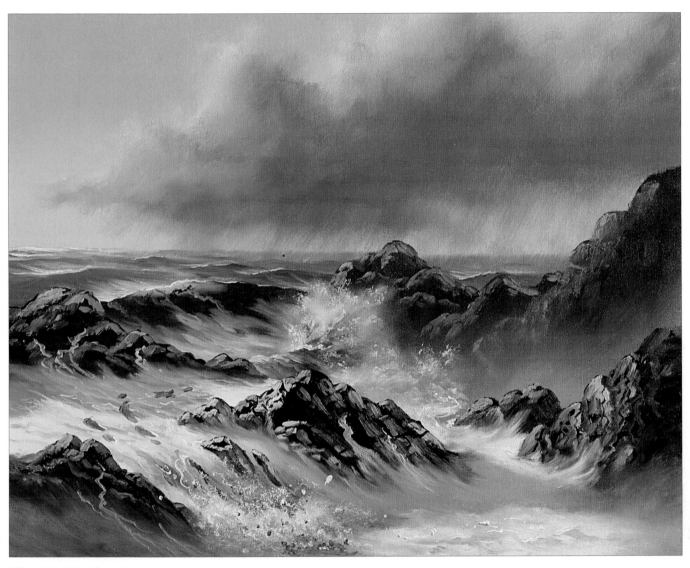

The finished painting
508 x 406mm (20 x 16in)

I relish painting this type of seascape with all its action. It gives me the opportunity to include the many details and tricks of the trade that can be termed 'stirring'.

Once you have finished, do not clean the palette for a while, because I can guarantee you that in a short time – perhaps an hour, perhaps a day – you will want to make a minor adjustment. I do every time!

Index